ART**NOW**

interviews with **modern artists**

continuum
LONDON • NEW YORK

Continuum

The Tower Building 370 Lexington Avenue
11 York Road New York
London SE1 7NX NY 10017-6503

British Library Cataloguing-in-Publication Data

A catalogue record for this book is available from the British Library

ISBN 0-8264-6371-1 (hardback)
 0-8264-6370-3 (paperback)

Design by Ben Cracknell Studios
Printed and bound in Great Britain by Ebenezer Baylis & Son Ltd, Worcester and London

CONTENTS

Introduction 4
Sandy Nairne, Director, National Portrait Gallery, London

Antony Gormley 8

Howard Hodgkin 28

Rachel Whiteread 46

Julian Opie 60

Mark Wallinger 76

Martin Creed 94

List of Illustrations 112

INTRODUCTION
TALKING AND LISTENING

Television can offer unrivalled access to an artist's thinking and working. In the transcribed TV interviews that follow, quite distinct from worked up texts in catalogues, six artists reveal sources and open up meanings for their works, the issues that concern them and even their obsessions. Little recognized, television is the best medium for this kind of investigation.

Some fifteen years ago three of us produced a television series exploring the ideas and images that were central to culture in the 1980s. *State of the Art*, commissioned by Channel 4 with WDR, included both Howard Hodgkin and Antony Gormley, and experimented with new formats and approaches in a documentary exploration of the contemporary visual arts. Illuminations, the production company for *State of the Art*, has pioneered new ways of bringing the arts to a wider audience, whether through network television, digital channels or the web. This new series, made with Channel 5, is rightly centred on interviews with each artist, with intelligent questions at its heart.

In the years since *State of the Art*, a number of presenters have become prominent – Andrew Graham-Dixon and Matthew Collings among them – but whatever their skills in narrating a documentary investigation, it is, more than ever, the artist that we wish to hear. Television executives and commissioning editors will frequently demand popular formats or gimmicks, but by and large there is no substitute for simply allowing artists to speak.

The place of contemporary art within our culture has also changed through these years. The successive achievements of British artists, marking an exceptionally fertile period, have engaged the interests of both a critical, professional audience and a wider public in Britain and abroad. Following the waves of new artists emerging in the 60s, 70s and 80s, the early 90s produced another set of talented, motivated artists, emerging in London through exhibitions such as Freeze, curated in Docklands by Damien Hirst. The new wave was evident in the energy of the exhibition programmes of independent galleries and arts centres across the UK during the 90s, and in the growing number of visitors each year to view the Turner Prize exhibition, publicized through the collaboration between Tate and Channel 4. The opening of Tate Modern in 2000 and the re-launch of Tate Britain in 2001 can be seen as part of a broader and very welcome set of changes in both audiences and institutions.

These are not six compatible artists. They are brought together somewhat randomly. But even if there are no direct connections, there are links and resonances, allusions and concerns that are very much of the second half of the 1990s and the first decade of the new millennium. Art bearing witness – consciously carrying individual and collective memory; art as investigation of the world around; art as a way of representing ideas in symbolic form, deeper or underlying meanings, often with a sense of the spiritual. The art spoken of here is good for all these things.

INTRODUCTION

Antony Gormley's work and ideas refer both to his own individual experience – connecting the making of the work to his own body – and to creating the collective experience of us all as witnesses: in response to the *Angel of the North*, *Quantum Cloud* or *Field*, for example. His is an art that is extraordinarily intimate and immediate, but produces a means to reach the metaphysical, the transubstantial. If Gormley's works start with bonding to his own body, moulded physically around his skin, then they extend, through the simple but highly charged materials that he chooses, to references about life, to the experience of being alive within a body.

Gormley relates *Angel of the North* both to a very strong childhood feeling about having a 'guardian angel' and to the broader idea of 'trying to look again at what the notion of a divine intervener might be'. To make this work was clearly an act of assertive power, an imposition as some saw it on the landscape and across history. But to accept that challenge and to make a connection, consciously, with the land – out of the earth where miners had worked – with a symbolism connecting to rebirth and renewal, that could and would be adopted at a political and social level, was artistic bravery of an extraordinary kind. The Angel has set new standards for art in public places and lays a challenge to other public commissions to create collective experience, not merely reflect it.

Howard Hodgkin's paintings take a long time in the making; they are famously worked and reworked over time. Looking at each of them is an experience of heightened intensity, not only in how the colours and shapes build patterns – often constructed out of contrasting hues and tones – but in the immediacy of an emotional charge. It is this resonance that links to the viewer's search for the place or person from which the work was drawn.

The personal experiences of the artist are private and remain so. Even when Hodgkin says 'it's matching what you do physically with the feeling in your mind', there is an idea of the connection, for the artist, between an idea, emotion, association or memory that may be the determining source for a painting and will be revealed through it.

The associations and rituals of painting as a practice and history, learning from other artists in the best sense, is evident in Hodgkin's commentary and in the work itself; these works have no innocence. The idea of testing new art against history and knowledge forms an active ingredient for the viewer. Hodgkin's consciousness, his way of 'standing naked . . . in front of art', is a form of identification rather than bravura in an age when, for some, painting has been discarded in the face of installation or new media.

The process of casting is central to the physical realization of Rachel Whiteread's work, but the process is also intertwined with the creation of meaning. Since the making of early works like *Ghost*, the cast of a single living room in North London, for which for she wanted to 'to mummify the sense of silence in a room, the air in a room', Whiteread has managed to capture the resonance of the objects she has used and the lives lived in the spaces she has embalmed. The sculpture becomes the carrier of the knowledge of lost memories, singled out and presented at real-life scale. The direct mirroring,

the translation of positive to negative, gives the relationship between the original and the work of art a peculiar reality – ghost-like.

Whiteread's most famous works – *House* in East London, the *Holocaust Memorial* in Vienna and *Monument* for the fourth plinth in Trafalgar Square – have shifted from a relationship between private experience and domestic space to an engagement with the political and public space of memorial. Perhaps because of the heated opposition that it aroused, *House* became a touchstone for contested issues of regeneration in the East End of London. The Holocaust Memorial, after years of debate over the site, succeeded with a quiet eloquence in making a closed library, a 'blank' but suggestive space in which viewers could explore their own meanings and memories.

The world as described by the works of Julian Opie transforms into a wonderfully ordered environment in which everything appears reduced to its essentials. He describes how his drawing involves a sequence of processes, controlled through a computer program, by which he makes carefully graded decisions that will produce the final portrait. Something is captured and recorded: 'Within an hour I've got a portrait, a new person, a character in my menagerie, and it's very exciting.' But what may seem deceptively simple, in the graphic intensity of the result and the bold colours of the surrounds and frames, comes through a view of the world that is intelligently selective and points at the idea or the kernel of things as much as their external appearance. This is reductivism with a purpose.

Opie refines the changes of scale in the production of different versions of a work, whether it is Blur or a rural landscape. There is a connection between the making of the image and the scale at which it is reproduced for public consumption. This was evident in reverse in the earlier, more caricature-like relief sculptures, where the world was much reduced. Now the world is selected and enlarged as a commentary on our culture. The public context is crucial, whether the side of a bus billboard or the regular scale of art in the museum. 'What does realistic mean? It means something that tallies with my, or your, experience of the world and that is, I think, not always photographic at all.'

Mark Wallinger's work of art, entitled *A Real Work of Art*, was a racehorse, acquired with a small number of supporters. It was hugely successful in extending Marcel Duchamp's idea of the artist designating an object in the world as a work of art. *A Real Work of Art* wore Wallinger's 'colours', created as part of an earlier series of paintings in which he explored horses being 'created' as a selective system of breeding. Sadly it was less successful as a racehorse.

Wallinger has also been exploring systems of belief, and *Ecce Homo* is the best known of his works. The Christ figure is placed in front of the crowd, but the tense biblical incident is translated to the fourth plinth, Trafalgar Square and our own time. The single figure, cast in resin from a real man, stood proud but diminutive in the context of the Square's monumental naval memorials, and brilliantly symbolized the idea of God as a man and His transcendence above the world.

Two video works by Wallinger, *Angel* and *Threshold to the Kingdom*, have also demonstrated his re-working of religious or spiritual messages. 'There's a yearning, a desire, that everyone feels . . . for transcendent meaning . . . it's the residue of a majority religious perspective within this secular world.' *Angel* uses the words from the Gospel of St John – 'In the beginning was the Word' – to create a prophet-like persona for the artist himself. *Threshold to the Kingdom* poignantly uses slowed-down footage of passengers arriving at an airport to imply that this could be a metaphor for arrival in a world beyond death: that we all face death as one of the few certainties of life.

Martin Creed is racked with indecision. His whole way of working is consumed in testing the limits of what might be considered by him to be a valid work of art. Because the range of options could, potentially, spread so wide, Creed is constantly having to examine whether he has got to a point of certainty: of something being definite, with a number and a description, ready to join the list of the works already made.

This issue of addition and joining things to the world, and also of impermanence, has been central to his thinking, explored in pieces like *Work No. 88: A sheet of A4 paper crumpled into a ball* and the neon message work erected on the front of Tate Britain: 'The whole world + the work = the whole world'. Another neon piece, on the temple pediment of an old building in Clapton, London, had the more upbeat message: 'EVERYTHING IS GOING TO BE ALRIGHT'.

The sense of philosophical investigation runs through Creed's works, which can lead to a certain level of ridicule. After winning the Turner Prize in 2001, Creed's work involving lights going on and off in a large rectangular gallery at Tate Britain led to more than the usual level of cartoons and puns in the popular press. But interest in his work prevails, and the simplicity and beauty of many of the pieces allows his art to occupy a higher level of enquiry, verging on the spiritual.

As Creed puts it typically and somewhat succinctly: 'Trying to talk about what I do, it's not very different from trying to do what I do. It's trying to do something. But I like trying to talk about it in the sense that sometimes I find things out by talking. Or listening.'

Listening is at the heart of this series.

Sandy Nairne
June 2002

ABOUT ILLUMINATIONS

Illuminations is a producer of cultural content for television, video and online. The company has made many programmes about the arts, history, science and ideas. Its documentaries, including its annual coverage of 'The Turner Prize' for Channel 4. have been acclaimed around the world and honoured with an Emmy, a BAFTA Award and numerous other prizes.

Illuminations has worked with many contemporary artists for its controversial and innovative series 'State of the Art' and 'Tx'. As a series of television films and as a book, *Art Now* develops the company's interest in creating distinctive content about the arts and culture.

ANTONY GORMLEY

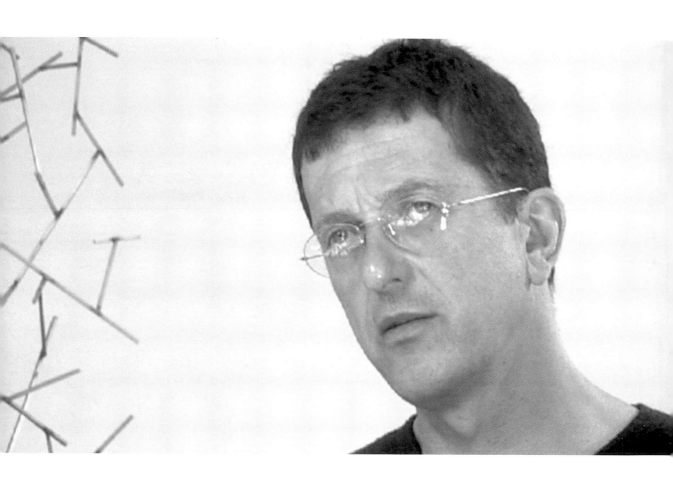

I'm trying to use my own existence as an instrument to explore the conditions of what it means to be alive, given this human body.

BIOGRAPHY

Antony Gormley was born in London in 1950. After studying archaeology, anthropology and art history at Trinity College Cambridge, he travelled in Asia before returning to London three years later to study at the Central School of Art, Goldsmiths' College and the Slade School of Art.

In addition to a series of important solo shows, Gormley participated in the international group exhibition at the 40th Venice Biennale in 1982. His work was included in several other internationally acclaimed exhibitions, such as 'Prospect 86' in Frankfurt and the following year's 'Documenta 8' in Kassel, Germany. Since then he has had touring museum retrospectives in Europe, Australia, Japan and the United States.

Gormley was awarded the Turner Prize in 1994. His critical success has continued since then with an OBE in 1997 and the South Bank Award to Visual Art in 1999. In the late 1990s his public sculptures were executed on an ambitious scale, epitomized by his most famous and award-winning artwork *Angel of the North*: a monumental masterpiece installed by the A1 motorway near Gateshead in the Northeast of England.

Throughout his career, Gormley has used his own body as the starting point for producing sculptures that demand a physical and emotional response. This preoccupation with the human form and with our shared spiritual potential raises profound philosophical questions about memory, the mind and our senses.

Antony Gormley lives and works in London and is represented by White Cube. He was interviewed at his studio in September 2001.

ANTONY GORMLEY

Can you start by discussing the direction in which your work is going? There is an idea of dematerializing the body that we can see in Quantum Cloud*, but also in the work since then.*

Antony Gormley: I didn't think of it as dematerialization. Right from the very beginning, the work has tried to describe the body not as an object but as a place. A moment came in the evolution of thinking about that problem when it was necessary to dispense with the skin, which had been very important to me up until then. I mean the skin as that thing that identifies the border between substance and appearance, which I'd been negotiating and renegotiating obsessively for fifteen or twenty years.

I've never accepted that the actual visible skin is the beginning and the end of the body because I'm very aware that we have field perceptions and that our perceptions of others are not limited by the visual. I tried to express it in the expanded pieces, which are very contradictory, because they're an attempt to make, in physical form, the most imperceptible energy field around the body. The biggest of them, which is called *Earth*, weighs about eleven tons, but in fact describes this very immaterial field around a fallen body. That is, as it were, the biggest expanded breath. And then I went to this final inhalation, which were these core works, called the *Insiders*, where we ended up with the residue, which I associate with pain. There was nowhere else to go after this final contraction.

Spontaneously, or, as a result of desperation, the body exploded, and that's where I am. How do you begin to describe that sensation I've always been interested in, which I first encountered in meditation: the sensation of the body as a place of becoming, where events happen. The body as a zone in which processes that we are not generally conscious of happen. After a number of experiments, I discovered that you could use little bars of steel, almost like needles thrown into the air. Assembling them in a random matrix, you could begin to make up fields that I began to think of in terms of Heisenberg's Indeterminacy Principle, or Uncertainty Principle, that had random connectivity. In other words, they would connect in a variety of angles, and there could be a variety of lengths of those elements.

At first, all I was interested in was somehow applying that principle to the body zone, and started making these pieces called the *Domains*. Then I realized that having started this random matrix as almost a precipitate or an organic connectivity, you could continue that sense of connectivity outwards and into space, and that's where the *Quantum Clouds* come from. Now when I'm making the *Domains* I use the Minimum Member Rule, which describes the zone of the body with the minimum number of elements. Every element counts both structurally and aesthetically.

Can you talk about the fact that it is almost always your body that you work with, and about how important it is that it begins with your body? How much is that a sense of the autobiographical and how much is it more abstracted?

Antony Gormley: It hasn't got anything to do with autobiography. It's entirely to do with reality and truth; easy to say and difficult to define. I'll try to deal with it as clearly as I can: I'm trying to use my own existence as an instrument to explore the conditions and what it means to be alive. To bear witness to that as precisely as I can, I have to use the instrument that I am given, which is my own body.

ANTONY GORMLEY

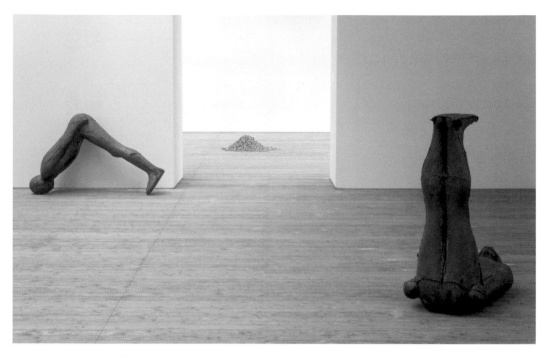

Testing a World View, 1993

Having said that, I'm not interested in portraiture, and I don't particularly want to celebrate my biography. I am interested that every work comes from a lived moment, in real time, that has been completely occupied. So each work starts from a moment of bare attention, where my concentration is completely integrated with this bit of the material world, which happens to be my body. That is my radicalism, that's the proposition that I'm making, which I think separates my work from the history of the body in sculpture.

I start from the premise: why make another body when you have one already? What are the advantages of using the body that you have? It's the only bit of the material world that you can work on from the inside. It's the only bit where you can make direct connections between consciousness and matter, because they are already there. So it bypasses all of the dangers, as I see it, of the body in sculpture of idealization, narrative, portraiture or sexualization for its own sake. I'm not interested in bodies that invite desire. I'm interested in the body as a place of becoming, because that's potential, and I still believe that we don't fully understand human potential. One of the ways in which we can do that is by objectifying the condition of embodiment in a new way. That's what my project is about.

I hope that that deals with the reality-truth side of the thing: each work is rooted in a lived moment. It's not important to me that people connect what they see with that, but I have a feeling that because it comes from a real, lived experience, it can evoke from the viewer a more empathic, particular and

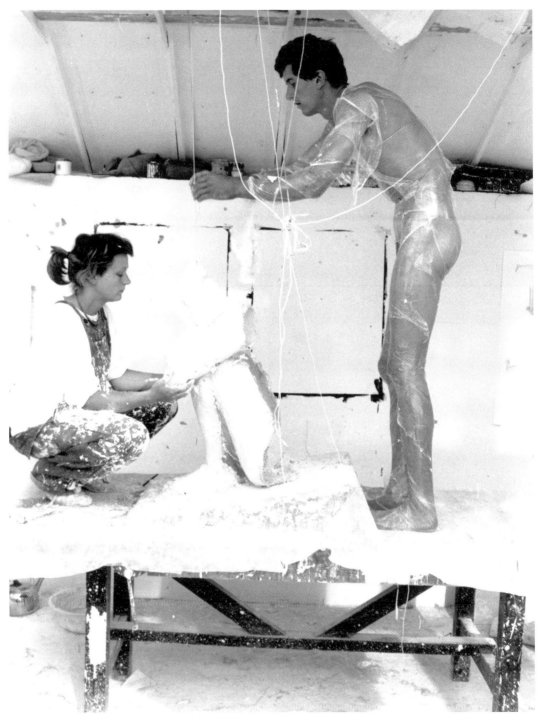

Casting process for the television series *State of the Art*, 1987

individual response. And that's important. In other words, irrespective of whether the person knows anything about art or this kind of discourse. I would consider my work to have failed if, somehow, it wasn't intriguing to people; because it bears witness to being a human being and being alive, I would hope that it should engage anybody, on a very basic level.

I don't think you need to know anything about art history to sense that this is like a sign of life, in the same way that you might come across a footprint of somebody in the middle of the forest when you were least expecting it, and be intrigued, immediately intrigued, and put yourself into that footprint. Where has he come from? Where is he going to? What kind of sign of life is this? And I hope that that's the sort of response that the work invites, that somebody can bring to it.

Can you talk more about putting the value on the individual, subjective experience?

Antony Gormley: The degree to which each of these works is an instrument for me to, in some way, confront myself with my own existence is, I suppose, also my perception of the potential for each of these works to be an instrument for other people to do something similar. And this isn't anything, therefore, to do with using a representational image to talk about things you ought to know about – the history of western civilization, a Greek myth, any kind of myth. It's an opportunity for a very simple sort of reaction, to ask 'What is this? What the hell is this thing doing here?' And the reflexive question that follows: 'and what am I doing here? And how am I looking?'

That is what the work proposes, which is, I would say, a reassessment of how art functions: where there is something recognizable, so there is a degree of representationalism, but that representationalism leads to reflexivity rather than a recognition of some already known ideal position or narrative story. What it does is it throws the viewer back on himself, hopefully. And the work then becomes like a kind of antenna, through which the space is somehow activated, and within it, the viewer's position, and, in some way, you just sense yourself as a being subject to gravity, illuminated by light, which are the kind of primal conditions of any object, including sculpture. Maybe you begin to feel that the subject of this work is not me, is not the history of the work and its making, but the experience of perceiving it.

For me, this is probably the most clear in the *Quantum Clouds*, where, in some way, the act of looking is the act of making the thing that you're looking at. You actually have to find it. It isn't described, it's a process. It describes a process, and the process continues in your looking, in your activity of looking. And your activity of looking, in some way, constitutes the work. It's very odd to me that, in many senses, a lot of the thoughts about this might better describe music, or more time-based experiences. On one level, I can acknowledge that it's very odd to use a medium like sculpture, which is so much about thing-ness, to try and do something that is so much about a transitive verb-type activity: being.

That's the extraordinary thing about sculpture, and the thing that continually compels me about it, that it is the dumbest of the arts, the slowest of the arts and for many people the most dismissible, the least necessary. But, curiously, I think sculpture, because it is dumb, because it is silent, because it is

still the best medium through which we can become conscious of consciousness itself. Conscious of our own mobility, of the way that our bodies and the way that our minds move constantly, so that as you move around one of these *Domains*, or *Quantum Clouds*, the way that the trajectories re-articulate the space that they're describing becomes a movie, which is somehow your personal way of experiencing this strange thing, that it is an axis for the time-space relationship.

Can we speak about some key pieces? Bed*, for example, which is very different from your later work.*

Antony Gormley: There were two very key works made in 1980, twenty-one years ago, where all of my work stems from. *Bed* was made at the same time as *Room*. *Room* was simply a room made from my clothes, which I'd cut into six millimetre wide ribbons, which were then expanded to make an enclosure about twenty foot square. *Bed* was the other side of the equation. If *Room* dealt with the relationship between our skins and the continuance of our skins, one of which is clothes and the second is architecture, *Bed* was an attempt to think again about what the relationship was between sculpture and a very fundamental mind-body problem.

If sculpture seems to be about trying to get mind into matter, trying to get this resistant piece of rock to carry an idea, or a feeling, I turned that on its head and thought: well, isn't actually the activity of

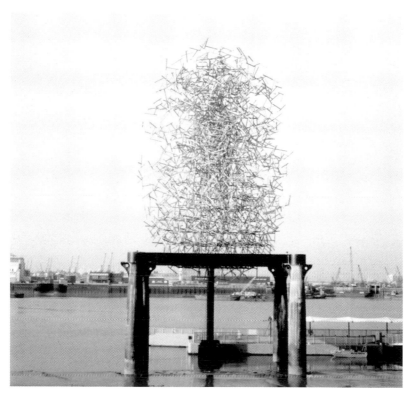

Quantum Cloud, 1999

eating itself a primary sculptural activity? Because it's the way in which material becomes thought. I wanted to make a testament to that, or I wanted to find a way of just presenting that problem, or perception. I had, for some reason, been chopping up pieces of bread to make collages, and I made a work called *Breadline*, which is simply a loaf of Mother's Pride laid out about a bite at a time. It was another way of taking an object that exists in that orbit that I'm always interested in, the orbit around the body, and redescribing it in the terms that we experience it physically, so it's just laid out, a bite at a time, and it makes a line about thirty foot long.

I hadn't eaten the bread at that point. And then I realized that it was possible to identify the space of the body, by making a negative of it out of a stack of bread. So eventually I made *Bed*, which is six hundred loaves of Mother's Pride, out of which, over a period of about three and a half months, I ate my own volume. I had a drawing on the wall, in red and green Pentel, which told me what I had to eat that day on any one layer of this contour map of the body. So I made a piece that was the shape of a double bed; I hadn't really thought about it before, I was just trying to find out the minimum stack size in order to achieve an equivalent of the volume of the body. And it turned out to be double-bed sized. In it lie these two negative half-body shapes that have very clearly been eaten away, and, because of each of the pieces of bread around the edge, you can see the bite hole.

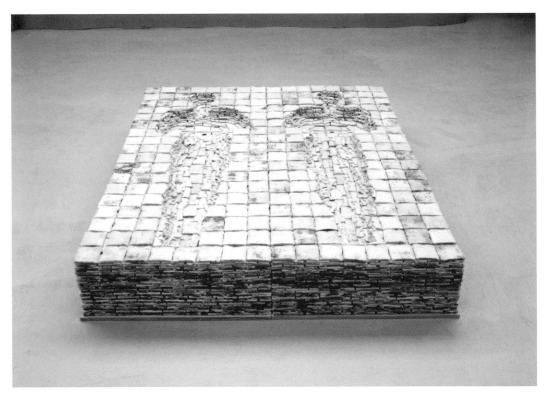

Bed, 1981

In the process of doing it, obviously the bread went mouldy. I quite like the fact; yes, well, here is a piece that directly deals with mortality, that directly deals with the stuff of life, and yet has its own life, can itself be the ground on which new life comes. Then, obviously, it was a question of how do you stop this inevitable process getting out of hand and the whole thing turning very smelly? So we dried it all out and then impregnated each piece of bread with hot wax and that's the piece. Extraordinarily, it's still around.

How did you come to begin working with lead casings?

Antony Gormley: It wasn't very long after making *Bed*, it was probably six months later, that I started work on *Mould*. I'd been thinking about the mouth as this channel through which food comes in and rarified thoughts come out, in words. I was trying to make a work that talked about the body as a processing place. This piece was the very first I made that actually used my own body in a precise way. It's me, basically, in a ball, with my mouth open, made as a plaster mould, which is about an inch and a bit thick, covered in lead. Very soon that was accompanied by two other works, one called *Hole*, which has the anus open and arse in the air, and *Passage*, which is a totally horizontal lying body form with an erect penis. The end of the penis is open, the anus is open, and the mouth is open. I called those works *Three Ways: Mould, Hole* and *Passage*.

What I was just trying to do was to identify, again, the body not as an object but as a place, a place of transformation, and by making an aperture in each one of these carapaces that were otherwise completely hermetic, I suggest this notion of things coming in and things going out of the darkness of the body – it being a place of transformation. That's where I've been ever since. It's a terrible admission in a way, because one would have liked to have thought that I could have got further, but I didn't realize then quite how compelling it would become, and how, having done one thing, so many other things became necessary.

Three Ways remains for me a very important piece. It identifies not just the beginning of my work but also the ground base of a whole zone of research. Rethinking the body as process not as thing, dealing with sexuality not as desire but as energy transfer. Dealing with embodiment not as a given, but as something that happens all the time, that is a continuing process. The piece after *Three Ways* is called *Three Places*. It is, again, a lying figure, and then a sitting and a standing – I don't like calling them figures, because I think that those works are all cases, they're very much boxes, they are skins that identify a place that was once occupied. *Three Places* is just about sleeping, waking and standing up, looking for something to do.

The one after that was called *Land, Sea and Air*. For the second time, I tried to deal with a connection of the body and elements. In that one, for the first time, I realized that it was possible to divide the surface in a very objective way, and that was very important, that realization that you could use given systems. *Three Places* dealt with the three basic positions of the body; *Land, Sea and Air* dealt with basic perceptions of sight, smell and hearing, and associated each of those with a particular element.

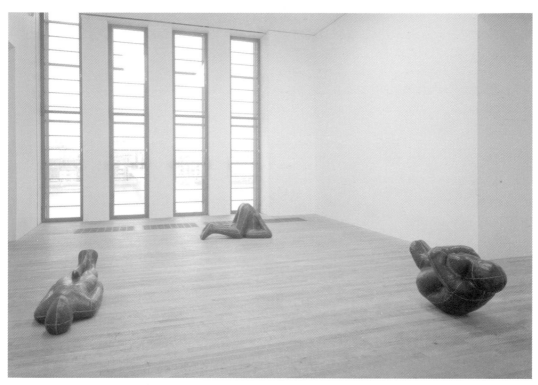

Three Ways:
Mould, *Hole* and
Passage, 1981

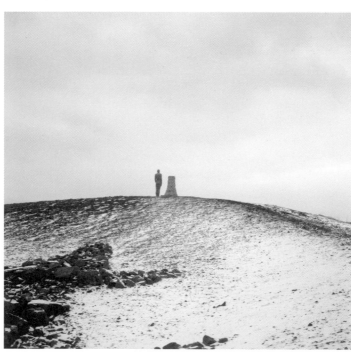

A View: A Place,
1985–86

There's a standing work with its eyes open, a kneeling work with its nose open, and a crouching work with its head tilted and its earholes open. The hearing is land, the seeing is sea, and the smelling is air. To make it clear, I photographed them on the beach, but I'm not sure it's necessary to see those works in that context in order to understand them. In fact, they went on to go into a foundation and they are shown indoors now, and that's fine as far as I'm concerned. The final threesome was called *Three Calls*, which evoked thought, speech and action. Those twelve works that were in four constellations identified an area of research that has kept me going ever since.

Some of the lead figures have an explicit Christian connotation which intrigues me. I'm thinking of both the standing figure with the stigmata and the one in the crypt of Winchester Cathedral.

Antony Gormley: I am a metaphysician. In other words, I'm trying to read the physical or find ways of reading the physical in order to find something that is hidden. And I don't want to get involved too deeply in discussing things that can't be discussed. The fact is that the two works you mentioned – an untitled work that was made in honour of Francis of Assisi, and *Sound II*, which is now installed in Winchester Cathedral – both have very clear references to Christian themes. One to baptism, and one to stigmata.

I grew up as a Catholic and was educated in a Catholic school, taught by monks. My sense was of a world where we lived and died, but that there was something about our being here that had to do with trying to find what that meant. I suppose what I was trying to do with both of those works was reconcile the fact that I am not a Catholic any more. I've lost my faith in the Catholic religion, my faith in religion as a vehicle of truth, and my perception of what truth was. I think that came from Buddhism and learning a very simple technique of meditation, which was basically dealing with what was here, being here now.

The piece in Winchester Cathedral is an attempt to reinterpret baptism, not as something that is divine and given by an external agency, but simply an acknowledgement that each of us holds this precious thing, which is life. It's not ours, because it moves through us, just as our body isn't ours, because we have to give it back. But in some way we are responsible for that moment, so it's a gesture of holding your life in your own hands. It's not difficult to see it as a religious image, if you see it in that church, that extraordinary phenomenon of the water coming in and out every winter, right there, underneath the high altar that was there a long time before the cathedral was built. That breathing of the elements, which is pre-Christian, somehow becomes the context for a work that, hopefully, is an instrument for people to sense their own beings.

Can we talk here about Angel of the North? *Is it a continuation of that engagement?*

Antony Gormley: Yes, I think it is. The *Angel of the North*, on one level, is me trying to make a physical statement about a very personal thing, which is the fact that, at an early age, I had a very strong feeling about my own guardian angel. I suppose I was trying to isolate that and look at it. It sounds a bit unkind to everyone else, that one would have to do it on such a huge scale. For me,

ANTONY GORMLEY

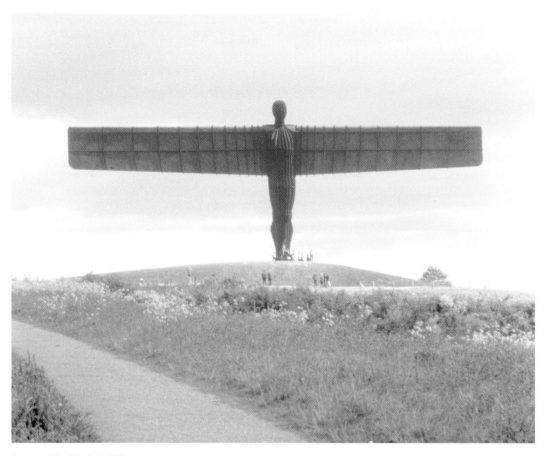

Angel of the North, 1998

there is a sense in which this is also an attempt . . . if *Sound II* and the *Untitled for Francis* piece both look at stigmata and baptism in the light of contemporary emancipation, so is this angel trying to look again at what the notion of a divine intervener might be.

I think it's probably more ironic than either of the other works, because it's evidently an object that's been made from the ground up, it's never going to fly. It's burdened as much as it is blessed by these hopelessly out-of-proportion wings. I'm trying to present there my own perplexity about what happens to human beings when they accrue to themselves attributes that were formerly considered divine. So what we're doing now, for instance, capturing our voices and our visible presence through binary codes and digital means, so that we can see visions of things that aren't there: on one level, that is the divine, this is miraculous.

The idea of being able to fly – up until 1911, with the flight of the *Kitty Hawk* – that was also something divine, miraculous. We've assumed these things as normal parts of human existence. And I suppose the Angel is an attempt to embody questions about how have we changed as a result of assimilating these divine attributes: to what extent are our bodies now dependent upon and implicated in technology?

The wing is a way of describing the fact that we have become irrevocably associated with technologies that we are now indistinguishable from. And that's a transformation. Even though it reads like a crucifixion and something very familiar, I think it is an attempt to say that this technology is a handicap as well as an advantage. I think it's trying to convey something of the loss that comes with the gain. Because once you've lost your arms, you can no longer touch the whole. It's rather like the fate of celebrity: you become useless in many ways. It's a meditation on that, it's almost like the despair of the sculpture that becomes an icon, so it's a meditation on its own redundancy. But I don't suppose these ironies will necessarily mean anything to the people who live with it and love it, which is an extraordinary thing, because I never imagined that they would because it's quite an ugly brute really.

It's become the best known and possibly the best loved public sculpture in Britain, and I'm curious about the public ideas of that and of other sculptures. How important is the relationship to a living, ongoing public?

Antony Gormley: Very important. I say it all the time, I think the art of our time has failed us if we can't live with it, and if it ceases to be intriguing long after it's been erected. We live in a time in which art aspires to the condition of cinema, and wants to be a show, wants to be an event. I would say that a lot of contemporary artists accept that absolutely as part of the job. In fact, they feel extremely uncomfortable with any notions of permanence, because everything is provisional. I accept that everything is provisional but on a slightly different scale. So I'd like to think that this piece is going to be there for fifty years and hopefully it'll be there for a hundred, and that people can live and die with it. That is a test that's important to me, that art doesn't have to have the special conditions of the art gallery, the private collection, the museum, to give itself a context in which it will work. It can live on the street, and people can pass it by every day. I'm interested in the quality that it may or may not bring.

How does having an imaginative object rather than a lamppost at the bottom of your street change the way you feel about life? I think it changes it fundamentally and I think it changes it for the good, basically. Having something that has no purpose but has been built with enormous purpose, that people have expended the same amount of energy and effort into making this thing as they would a bridge, or a ship, or any other bit of human invention. And that it has no purpose other than to, in some way, be an object in mind. It is an extraordinary thing that here you have this physical thing, it actually exists in space, but where it really lives is in people's memory.

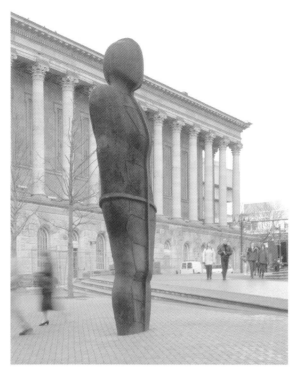

Iron: Man, 1993

That's very exciting, and I think if you can find within culture – maybe culture's not the right word – but if somehow you can get the resources in order to realize those things, it makes a difference, I think we may be getting somewhere in terms of making art central to, or part of, the core ingredients of everyday life. I want it to be there, that's where I think it belongs. It's one of the few areas left where people can actually disinterestedly think about their own freedom and choice, and if imagination is not involved in that, if it's simply a matter of money and what you can buy with it, we are diminished. The wish to have a transformative environment which reflects the possibility within each of us that we can actually transform ourselves, that we don't have to be victims of our own history, that we don't have to be victims of our immediate circumstance, that we actually can be in some sense masters of our destiny, that we can, in some way, fulfil our dreams, all of those things – I think they're very important to me.

Could you describe and talk about Still IV?

Antony Gormley: *Still IV* is a lead moulded case made around Paloma, my youngest child, who's not very young any more, but it was made when she was six days old. It's one of the works which is not taken from my own body but one very close to me. It wasn't actually made as everybody thought from a moulding of her. As she was sleeping I carved her out of polystyrene.

Seeing it now [at Tate St Ives] it's very important to me because it was the first time that I've shown it in a public space and I was very pleased with the way it worked. It's a transposition. This is a moment of intense intimacy and closeness. A very young child that would normally be found like that on the stomach of the mother, maybe after feeding, and that sense that I hope the sculpture carries of contentment, quiet. But it's just been shifted from that closeness to another body: to the ground and then been isolated.

I hope that it carries something of the basic dichotomies of human existence. That from the moment that we leave the body out of which we came, to the moment when we return our body to the larger body of the planet, we're on our own in one fundamental way, that we have a skin that isolates us from everything else. I was just trying to make that point, and through making that point summon up in people the need for closeness, the need for intimacy, the need for all of those very human senses of protectiveness, compassion, concern.

I don't want to load it too much. It was, I guess, a way for me to understand my own responsibilities as a father. But I suppose like all of the work I was just trying to make a bridge from this particular case and this real lived and living body to a more general condition. It can be associated with so many things; I don't think I need to spell them out, whether they're to do with female infanticide or to do with abortion or whatever. The fact that it's called *Still IV* has this double edge.

All my titles are quite important in so far as usually they are a noun and a transitive verb. They describe a thing as well as a state, and that degree of double entendre in the title – between the idea of 'still' meaning continuance and the idea of 'still' meaning dead – is part of the emotional power of the work.

Emotion is one of the things that sculpture has not been good at dealing with in the twentieth century. Art is capable of carrying feeling, and often feelings that can't be conveyed in any other way. I suspect you'd say, 'oh this is all very sentimental'. I am not entirely sure that that's right. I think you could say that one of the experiments that *Still IV* was trying to do was say, can I make a very tiny object that rather like a bomb can have extreme effect? Can I insert into a public space something of such acute intimacy that people will be emotionally affected by it?

Can we perhaps extend those ideas in talking about Critical Mass*, which was also shown at Tate St Ives?*

Antony Gormley: *Critical Mass* is the absolute opposite of *Still IV*. *Still IV* is in some way about the fragility but also the excitement and sensitivity of those first days of human life. *Critical Mass* is in some sense an anti-monument. It's a monument for something that we hope will never happen, which could be a nuclear or, in these days, a chemical or biological attack that has allowed the body to fall out of its ordinary position, but holding within it a memory of what that was.

Opposite *Critical Mass II*, 1995

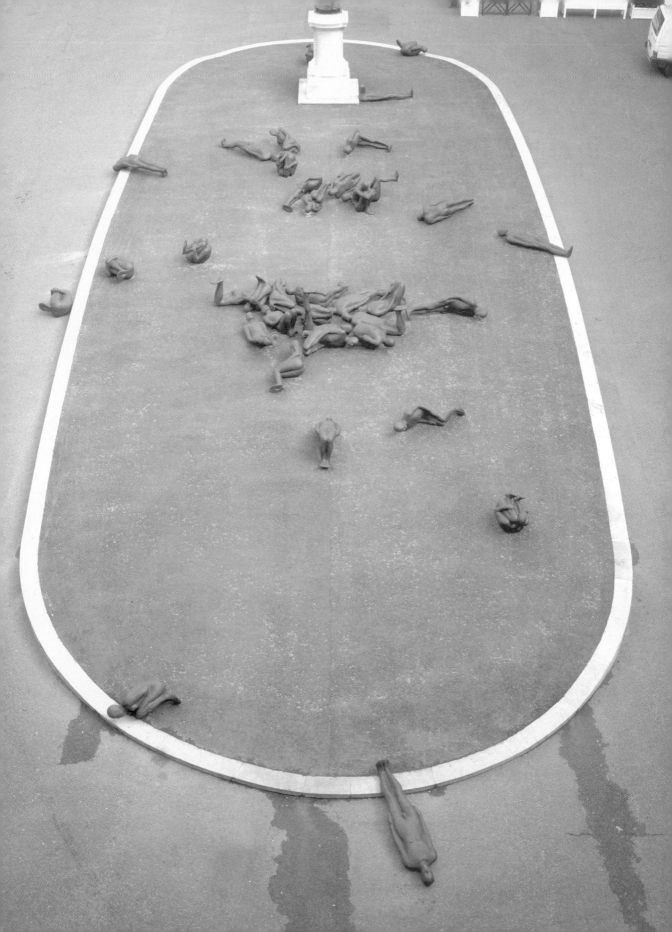

We have there twelve positions that I articulate as a kind of lexicon of the basic body postures which have then been tossed around, literally. To organize how they went I made a model of the gallery and literally threw them in – and that was very important for me, this random element. Rather like the elements within the *Domains*. So the elements found their own position through gravity, and there's a sense of order and disorder in equal measure and that you are allowed to pick your way through it. You then watch others pick their way through it.

There's a sense in which *Critical Mass* is also asking quite big questions about where bodies fit. In the end we're all lost in space and here are a whole load of bodies that have just sort of fallen from their ascribed positions into a muddle that reminds us of another form of fragility. It reminds us of Rwanda and Cambodia and any number of those terrible moments in the last hundred years.

Can I ask about Field?

Antony Gormley: It seems very odd, even to me, that I've set myself this twin problem, which is how do I bear witness to my own existence, but how do I also try to articulate something to do with the collective body? How do these very archaic ambitions to make sculpture have some kind of social role? I'm trying to combine those two things, and I think that probably it does come together most effectively in *Field*.

Field, while being an image of the globalized, multi-cultural democracy, and therefore utopian on one level, is utopian with a twist because it may present the unborn as existing on an absolutely parallel plane. They're all looking for something. They're evidently anxious. They're obviously concerned, and what they're looking for is us, looking for bodies to haunt. Consciousnesses to infect. *Field* is probably my big cry of conscience. Here I am quietly messing about with my mind-body problems in my own studio, but I want somehow to make a work that deals with . . . well, with what the hell are we doing about the fact that the population is exploding? That there are less and less resources? That the resources that are there don't seem to be very well distributed?

I think what *Field* expresses is an anxiety about what kind of world we are bequeathing. It puts each of us in the position of God. We are the makers of the world and we are the people who are in charge, while we're alive, of our own lives and in some way of everyone's. There is a sense in which *Field* carries this very atavistic, very old spirit of the ancestors – the Earth and its memory of what went before. More importantly it is about the unborn and what we are doing to make sure that the world that they come into is worth coming into at all.

Being an artist I suppose one's always in danger of, I don't know, fiddling about doing the things that one likes to do rather than being responsible, so there's a sense in which *Field* is an attempt to make a responsible work of art. Whether there is such a thing as a responsible work of art, I don't know. But

Opposite *European Field* (detail), 1993

it's interesting, responsibility. What does responsibility really mean? You could say that responsibility is a way of just saying that you have to listen and act on your responses.

I'm very keen on the idea that art is an instrument by which we can listen to our inner voice, which is the real director or the real authority, and if we are responsible we respond. Hopefully that is what *Field* does. It takes a certain anxiety about what kind of world we are making and makes it into a collective experience. Interestingly enough it was also a collective experience in the making, which is very important. It was generated by a lot of people coming together and trying to be aware of what they were doing – in a new way, perhaps.

The idea of the social takes us to Allotment II, *which is the last piece I was keen to have you talk about.*

Antony Gormley: *Allotment II* and *Field* are absolutely two sides of the same coin. *Allotment II* says, OK we all have bodies but we also exist within architecture, and architecture in some way is the second body. What I was trying to do was take the second body as the descriptive medium for the first. So I invited, through advertising in newspapers, through the radio and television, volunteers to come forward to have themselves measured. We had 300 people from Malmö [in Sweden] who were very intimately measured – the distance between your ears and the distance between your chin and the top of your head and the distance between the top of the head and top of your shoulder and the widths of your shoulders and then the height of your arsehole above the floor and similar genital measurements.

All of those measurements were then transferred into an orthogonal bunker architecture, which had no eyes, but had orifices at the ears, the mouth, the anus and the genital area. They are all exact. The walls of each of these spaces, which I call 'rooms', are five centimetres thick, with steel reinforcing, and they could be occupied. If one had a crane and one stood very still one could have one's own room lowered on top of one. But I like the idea that none of them have ever been occupied, even though they could have been. And I like the idea that some of the people are now dead, that some of the people have shrunk and some of them have got bigger.

In some curious way this virtual city represents a particular moment in time, so it's a kind of memory of a community that's a ghost town. And each of these rooms contains darkness. You can look at this darkness through the orifices and think about what that space means. This identifies the minimum space necessary for a human being to be alive and it talks about lots of things. It's a labyrinth – you can get lost – but there is order. There are two avenues and four cross streets in this present installation, but actually it's easier to wander through than to follow the orthogonal system. I suppose what I'm inviting you to do is to get lost in this labyrinth, in this maze, and maybe in the process to think about what a strange animal the human animal is, that we have invented this nest that isn't really a nest.

ANTONY GORMLEY

We have invented a system of articulating space around us that is entirely abstract, but exists on absolute principles of orthogonal organization, and that is where most of us live. Ninety per cent of human beings now live attached to the urban grid. I suppose it's an invitation for people to think about what effects that might have on how we conceive of ourselves and how we act, but there's no judgement in this. The space that this work inhabits is a curiously abstract one. In other words it's a kind of limbo.

I feel that I can hear the whisperings of intimate conversations or soliloquies and somewhere within this almost Mengele-like project there is a recovery and a certain kind of innocence. You'll find that there are adults and children placed in a wide variety of different configurations – two adults standing back to back, maybe one of them with a child, or an isolated child surrounded by a group of six or seven adults looking inward. Anyway, once you descend into the very slow, still, ambient vibration of the piece, you can begin to hear or to see relationships.

The experiment in this work was how do you take this moment of vulnerability and extreme intimacy, a naked person being registered through the abstraction of numbers into a number of measurements and co-ordinates, transfer that into this idealized architectural form, and what do you hear through the resulting re-embodiment? I think there are all sorts of things that you hear, to do with human frailty, to do with longings for closeness. I think cities themselves are extraordinary expressions of this, the fact that human beings like to be together. But then all the walls are an admission of being together but not necessarily that close. That's what *Allotment II* is for me.

We get given this bit of the material world which renews itself every seven years, we sail with it for a life-time and then give it back to the earth. But with this body we also then inherit this environment that is attached to an alimentary and nervous system that has been laid down often decades if not hundreds of years earlier. And we accept that as our second body, as our context. We animate it and make it our own, so we identify very strongly, each of us, with a particular street and we inhabit that imaginatively, we extend our feelings into it. That's what neighbourhoods are about and the whole debate about the relationship between the local and the global. That is the texture of it. How human beings manage to feel for that bit of the physical world that lies immediately next to their bodies. That's what I hope *Allotment II* tries to evoke while being at the same time extremely distant, being a very cold place to lose yourself.

HOWARD HODGKIN

I'm very conscious of the past. . . . It's amazing how so much modern art is a comment on what has gone. For obvious reasons nobody can comment on what is to come. But I've always thought that art breeds art. Art comes from art, and that's why the past is so important.

BIOGRAPHY

Howard Hodgkin was born in London in 1932. Between 1940 and 1943 he lived in the United States, before returning to the UK to attend Eton and Bryanston colleges. He later studied at Camberwell School of Art, London, and Bath Academy of Art, Corsham, graduating in 1954. Hodgkin first taught at Charterhouse School, Surrey, and then Bath Academy in 1956, where he would remain for the next ten years. His first one-man show was held in London in 1962. From 1966 to 1972, he taught at Chelsea School of Art and was visiting lecturer at the Slade and Chelsea Schools of Art from 1976 to 1977.

Hodgkin was appointed a trustee of the Tate Gallery, London, in 1970, and of the National Gallery in 1978. His first big retrospective exhibition was held in 1976 and he was awarded a CBE in 1977. During the 1980s, Hodgkin spent time in India, where he became interested in its rich painting traditions, before returning to represent Britain at the Venice Biennale in 1984. He won the Turner Prize in 1985 and was awarded a knighthood in 1992.

Howard Hodgkin is respected internationally as one of the most significant artists at work in Britain today, producing paintings that uniquely straddle representation and abstraction. Beginning with a remembered experience, Hodgkin works on his paintings for long periods, often several years, characteristically producing richly coloured, sweeping compositions, which continue into the picture-frame itself. Hodgkin's interest in working in different scales is evident particularly in his more recent paintings, such as *Americana* and *After Vuillard*, which are significantly larger works that engage the spectator in very different ways.

Howard Hodgkin lives and works in London and is represented by the Gagosian Gallery. He was interviewed at the Charlotte Street Hotel in March 2002.

HOWARD HODGKIN

In 2001 you hung a number of your recent paintings with the collection of old masters at the Dulwich Picture Gallery, and I'd like to start by talking about that exhibition. Did any of the juxtapositions please you? Was it pleasing to see your work alongside any of those masterpieces (and some not-so-masterpieces)?

Howard Hodgkin: It was a tricky problem because in the collection at Dulwich there are great pictures and there are many which are not. I was very pleased indeed that *The last time I saw Paris* stood up to the Poussins. And though the usual suspects were all saying how dreadful and weak and silly my pictures were, I did think that really worked. I also thought that *Rain at Il Palazzo* worked very well. And I was fascinated by the audience reaction.

Because?

Howard Hodgkin: Well, working away in a studio by yourself you don't get much usually. Particularly at the opening; as it's a small gallery you can hear what everybody is saying . . . and they did look at my pictures and didn't think that they were an insult – most of the people – to what was there already. The huge picture called *Chez Max*, which is round and blue – a lot of people liked very much. It was interesting coming back at the end of the show because lots of people seemed to have come for the second or third time and everybody was very vocal.

Did you think of yourself as competing with those masters?

Howard Hodgkin: Not for a second! Which of course I'd said in the catalogue. There was no question of competition. I think that's why it was so different from Lucien [Freud]'s exhibition there, where I think he was trying to say – perfectly naturally – that [his painting of] the benefits supervisor was just as exciting and splendid as a painting by Rubens. I think that was perfectly true, but I didn't feel at all like that.

But you are very conscious of working in a long tradition of painting?

Howard Hodgkin: Yes, I'm very conscious of the past, and I once made a very glib remark in an interview with someone saying the past is the only home we've got. It is a silly remark, but it's also true. It's amazing how so much modern art is a comment on what has gone. For obvious reasons nobody can comment on what is to come. But I've always thought that art breeds art. Art comes from art, and that's why the past is so important.

Do you still look at a lot of painting by other artists? Do you still get pleasure from that?

Howard Hodgkin: I still look at paintings on an almost continuous basis but I don't go round looking at other shows in the way I did when I was young. Naturally enough I now begin to think there isn't much time left. Also there are very few people painting at the moment.

HOWARD HODGKIN

The last time I saw Paris, 1988–91

31

HOWARD HODGKIN

So do you feel beleaguered as a painter?

Howard Hodgkin: No, not at all. No, maybe people will start taking me seriously now there are so few painters. No, I don't feel beleaguered, but that's also partly because of the audience.

Do you think the audience has grown to like what you do more? In the past you've been concerned about the audience and reception and appreciation, perhaps particularly in England . . .

Howard Hodgkin: I've never been worried about it anywhere else! I still don't think people like painting very much in England . . . I think the general public does more and more and more but . . . intellectuals don't very much. I ran into Germaine Greer the other day and I said some vacuous remark. One should never, I was once told – and I think it's true – thank a critic. I said: 'Thank you for saying those things about my work on *Newsnight*.' And she said, 'Thank you for what? The British are blind!'

I wouldn't go that far but I knew what she was talking about. They aren't at all blind, but they find it – I don't mean to be polemical – but I think they find it very much easier with the work of dead artists than living artists. I think they need that distance. Having said that, I really don't think they like painting very much and I think it's no surprise that the many extremely good artists that there are now who don't express themselves through painting at all should perhaps have been accepted so quickly. It's a very English thing.

Can I ask about Englishness? Do you think of yourself as an English artist?

Howard Hodgkin: Never! . . . I don't think of nationality as being very important. In some ways I'd like to be thought of as an English artist; in other ways I'd hate to be. What is an English artist? What is an American one come to that? At different times, it means different things.

Turner and Degas, say, are great forebears, but are their nationalities not important?

Howard Hodgkin: Not to me, no. I don't think of Degas as particularly French. He is obviously extremely French once one starts thinking in nationalistic terms, but I hate that. I don't think compared, for example, to the rhetoric of written French, which is perhaps fortunately unique to France, there's anything in Degas' paintings that is unique to France.

And nothing in Turner's that is unique to England?

Howard Hodgkin: There's a lot in Turner's career which is unique to England. The fact that he had to spend so many years producing little pot-boiling views which were then engraved and sold like compact discs are now, to get money to feed his imagination – I think that's very English. It's perhaps almost sacrilege to say so, but I don't think his early topographical, very careful watercolours of Durham Cathedral, the High Street in Oxford and so on are really why we think he's such a great artist. He's an extraordinary painter. Did you see the exhibition at Liverpool last year without the frames? It was incredible.

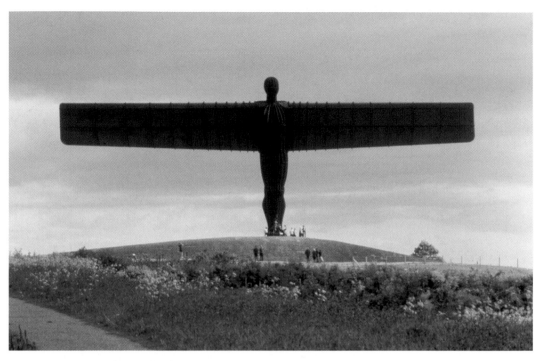

Gormley: *Angel of the North*, 1998

Gormley: *Still IV*, 2001

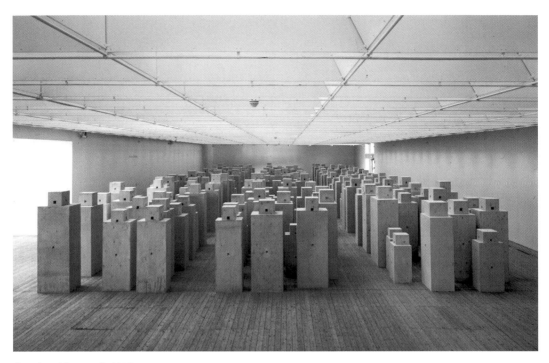

Gormley: *Allotment II*, 1996

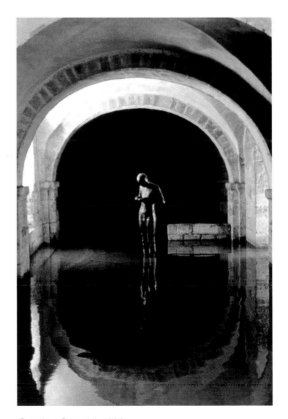

Gormley: *Sound II*, 1986

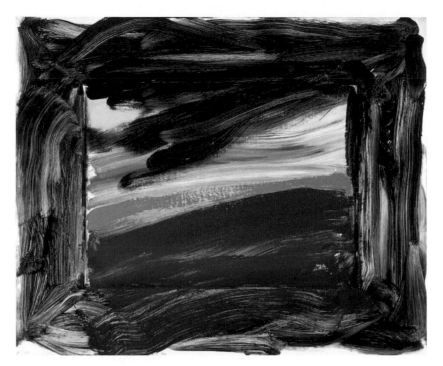

Hodgkin: *Americana*, 1999–2001

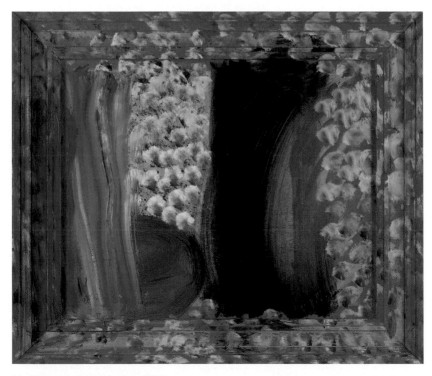

Hodgkin: *After Vuillard*, 1996–2002

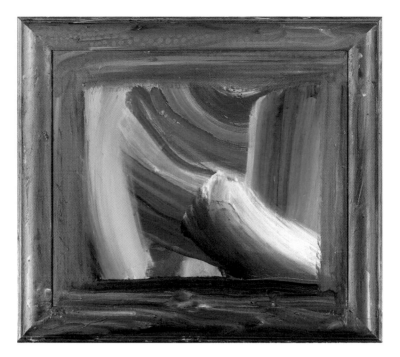

Hodgkin: *The last time I saw Paris*, 1988–91

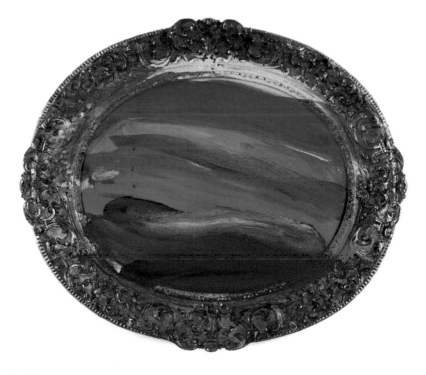

Hodgkin: *Out of the Window*, 2000

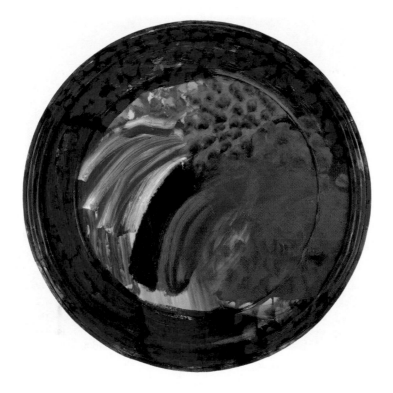

Hodgkin: *Chez Max*, 1996–97

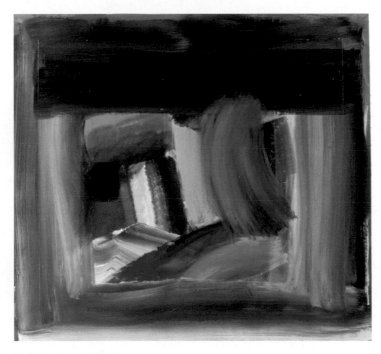

Hodgkin: *Rain*, 1984–89

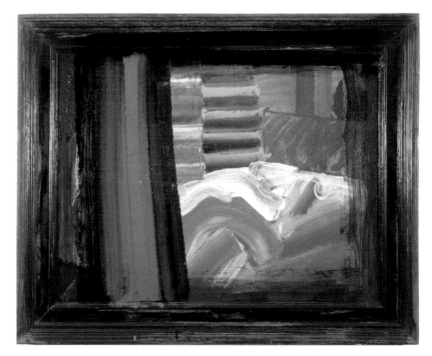

Hodgkin: *In Bed in Venice*, 1984–88

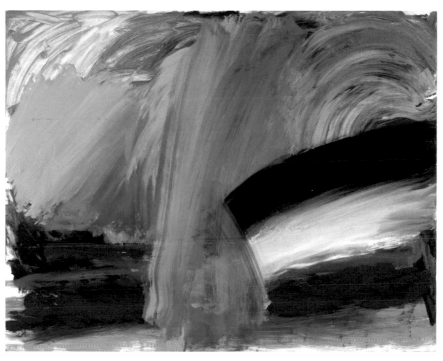

Hodgkin: *Rain at Il Palazzo*, 1993–98

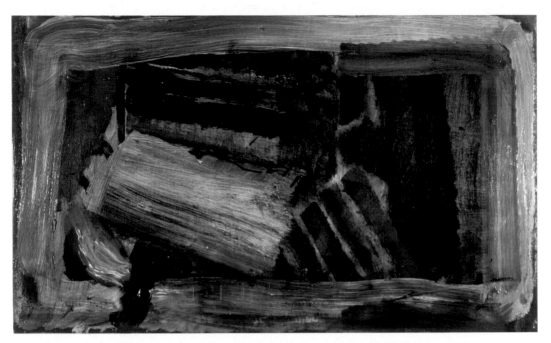

Hodgkin: *Clean Sheets*, 1982–84

Hodgkin: *Mr. and Mrs. E.J.P.*, 1972–73

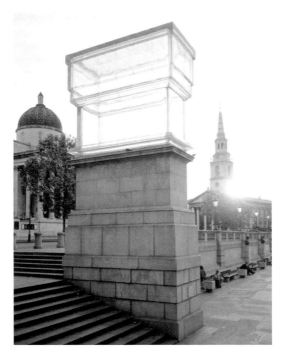

Whiteread: *Monument*, 2001

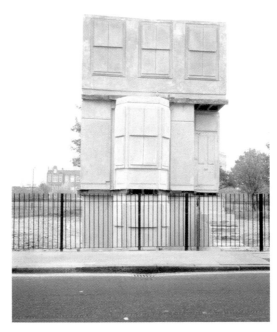

Whiteread: *Untitled (House)*, 1993

To see it in that light as well was very strong.

Howard Hodgkin: It made sense to what you saw out the window . . . in an amazing kind of way, but I don't think that's purely English.

Did you always want to be a painter?

Howard Hodgkin: Yes! Now that is an easy question to answer. Yes, since the age of five. Because at the age of five I remember doing a terrible, of course, bit of child art which would really not have pleased lovers of child art, because it was too careful and too ambitious, in a way, of a woman with a red face. And somebody being patronizing said, 'Ahhh, what do you want to be when you grow up?' And I said, 'A painter,' which of course was repeated to me in subsequent years. But oddly enough, it was true. I can't remember what I thought when I was six or seven and so on, but when I was still a small child I was determined – and then the trouble began . . .

The trouble being a context and an education system which was unsympathetic to that ambition?

Howard Hodgkin: Yes and no. It's rather complicated because . . . I felt that it was . . . and for various reasons – not personal riches on the part of my family, but because of other people – I was sent to a very grand school in America where I was during the first half of the War. There was a very good art teacher who was an aggressive woman who knew all about art and disliked me intensely, partly because some of the other pupils thought my art was very interesting – probably because I was talking about it too much or something. But it was very useful to me because it made me realize what an outsider you were if you wanted to be an artist in the circumstances I was in.

There were far fewer amateur artists in America than there still are here. It's very strange but apart from playing certain musical instruments, I don't think there's any other art form where there's a sort of idea in the back of people's minds that anybody can do it. But after that, I was quite lucky. I had a series of insane art masters in different schools, the first of whom was Anthony Blunt's brother Wilfrid. He was a superb teacher and a tremendous tease and he did have some sort of social idea of what art does and doesn't do, and that's very important to any art student.

When I was a teacher, which I was for far too long, I used to talk to the students about that more than anything else. Funnily enough, I was talking to somebody about this last night, a very well-known literary-critic/writer, and she said, 'What a pity Tracey Emin couldn't draw' and – this shows the high level of this discussion – I said, 'She happens to have been the most talented student of her year at the Slade, best at life drawing, best at life painting and so on'. So we had a long conversation about all of that, but the fact remains that what artists do cannot beyond a certain point be taught. People have to teach themselves. You cannot teach the authenticity required by art.

I remember having a very long and bitter argument with Ron Kitaj and David Hockney in a Chinese restaurant years ago in New York. Kitaj was doing his number as ever – 'There's a lost generation' – he was being Hemingway and Gertrude Stein and everybody at once – 'and they can't draw.' And I

Memories,
1997–99

HOWARD HODGKIN

said 'Well, you know, if you really think so you should go to the Beaux Arts in Paris where they have kept all the life drawings by all the students who've been there since about 1810 and you will find of course that year after year they stood in front of a nude model and the head had to touch the top of the page and the feet the bottom.' The great American art historian Robert Herbert wrote a book about Seurat's drawings and said, 'It's amazing how, when he went on his military service he suddenly learnt to draw, having spent years at the Beaux Arts, what happened?' Kitaj was trying to say it was all those years and I said, 'No I'm sorry, I've been trying to teach drawing to people for years and that isn't quite how it works.'

Where does that authenticity come from? Is it some kind of innate talent?

Howard Hodgkin: I think innate talent is greatly overrated. Yes, there has to be some kind of sensibility, but the sort of sensibility that enables people to do things – whether it's to sing or be a musician – that comes from a willingness to be naked in front of art.

It may sound ridiculous . . . and then, having got that far, some ferocious moral impulse. Ambition is far more important than talent. I spent about five years of my life, horrible to relate perhaps, being the admissions tutor at art school and having to tell mothers and fathers that, yes, their little girl was very talented, because girls tend to be more talented, visibly more talented when they are at school than boys, who develop more slowly. But that wasn't really it, and I found that very hard to explain – as I am now . . . but it's worth remembering that Margot Fonteyn, for example, started dancing because she had faulty ankles – these sort of disadvantages stiffen the will in some way and that's what really matters.

Some people would see a contradiction between that ambition and the other word you just used . . .

Howard Hodgkin: Authenticity.

Well, I was going to say morality.

Howard Hodgkin: I don't think there's any . . . you think it's immoral to be ambitious?

I think there's an English sense that perhaps it is immoral to be ambitious.

Howard Hodgkin: Perhaps I was very lucky that I spent the formative years of my childhood in America, I've never thought of this until now, but I think you're right. Yes, it is thought to be immoral, but curiously enough, at a certain level of society . . . it's in middle-class terms that it's immoral to want to be very good as an artist, it's not immoral to want to be an investment banker, for example, or even a diplomat or writer.

But I think you're right . . . when I talk about morals, I'm also talking about morale. Verbally, this is difficult but I spent a lot of time talking to my pupils about opening themselves up to art if they wanted to. Then just being ambitious in my book just means trying as hard as you possibly can. But there are no five finger exercises for painters – drawing from the nude model is not a five finger exercise and

many people for years have thought – they still think so – it's an easy way of saying, 'Oh, but they can't draw'. I remember my mother, even, saying Augustus John couldn't draw. He couldn't, in a way, but he was a wonderful impersonator of a great draughtsman; he could draw like all sorts of artists and then occasionally he did miraculous things like his portraits of James Joyce. Have you ever seen those? Just a single line. They're wonderful.

Going back to the argument I had with David and Kitaj, I was saying what a great draughtsman Matisse was and they were saying, 'Oh yes, yes, yes!' Because he had drawn some very strict tempo drawings as studies for not one of his best pictures – it's very self-conscious, called *The White Plumes*, and they're almost . . . They are extremely representational in a language which is quite easy to understand as being representational . . . but he'd passed that long afterwards when he was able to just put either no eyes on a face or just two dots and two eyebrows. They were not willing to take that on as being . . . they couldn't say it was bad. I only mention that because I think we would all agree that nobody knows what art is, but they know it when they sense it. How can you teach people that?

Are you still learning?

Howard Hodgkin: Oh absolutely! I'm delighted you asked me that. I feel I'm learning every day, but that's the kind of thing old artists like to say. I can think of several who I won't name who say every day is better. I'm not saying that for a minute, but of course one's learning and you learn by doing – always bearing in mind you are doing your utmost not to deceive yourself.

And how do you know that?

Howard Hodgkin: You know that because you know about art . . . you have to be . . . I'm sorry, I wish I could remember it verbatim but Matisse, like most artists who write a lot or talk a lot, was full of hot air and rhetoric; nevertheless he did say in one wonderful sentence, 'Nowadays an artist is completely on his own.' He has to be his own patron, his own critic, and – I can't remember, he had a very discreet word for his own . . . what we would call a publicity agent, but it wasn't anything as crude as that, his own commentator I think . . . he also had to beat the drum for himself. It's hard to think of a great twentieth-century artist for whom that's not true. Now we know almost too much about Picasso's life, we know what immense time and trouble he had to spend on doing that. It seems to me a pity.

Because all that takes you away from the core process of painting?

Howard Hodgkin: No. I think the core process of painting is to some extent conditioned by all of that. So no, I wouldn't say that exactly. But it's only in England there is this curious sort of morality trip that people have. It's so much easier to say that this person is wicked or shallow or whatever, rather than looking at what they do . . . and apart from the writings of Sickert there are very few people around ready to challenge this sort of backlog of rather silly ideas, these prejudices.

HOWARD HODGKIN

I'd like to ask about that process and about being alone in the studio. What is it like? I think I understand why you are so protective of the studio space, and I'm curious about the experience of being there.

Howard Hodgkin: Well, I'll start by describing my studio, which is a very big room with a glass roof and white painted walls and a white painted floor which over the years has acquired a lot of indelible marks. It's hard to work there in the summer, because it's so bright. You have to get up very early and work in the early evening. Being in it is utterly lonely.

I do have assistants but not many, not like a sculptor would have. But I can't use my assistants to make my work – I wish I could, I don't think it makes it less authentic, but I simply can't because of the way I work.

Being in that white room without anyone to talk to, it's quite demanding and so I think, well . . . it's time to have a cup of coffee, or five minutes later it's time to go out to have a cup of coffee again. Or I just go across the road to the British Museum. The trouble with being in your studio is that there is nowhere else to go. I haven't got a window I could look out, I can't even see the clouds in the sky, and the loneliness is something that I have never really got used to.

Is it pleasurable or is it painful, being in the studio painting?

Howard Hodgkin: Oh no, I hate painting. There's always a wonderful moment, however, when finally I decide the painting is finished. And then, less and less now because the time is getting short, you think I've got to paint another one, or rather finish another one, and being alone with your deadlines in your studio on the one hand, and alone – for want of a better word – with your muse, which keeps going away, or disappearing round the next corner; it's not easy.

I used to be very jealous of other artists . . . not particularly because of fame and money, but because of the way they worked . . . I particularly used to be jealous of Lucien, because he had people to talk to, and his sitters saying what a wonderful conversationalist he was. And I thought talking to someone while you're actually thinking about something else must be marvellous, and Sickert The Great used to read trashy novels while he was painting. Well I've tried that, reading really trashy novels and reading them again and again. Somehow that wore off, and so I tried newspapers, and nothing makes you more critical than reading newspapers more than once. Anyway, I do things like that.

Do you listen to music?

Howard Hodgkin: No, too distracting.

Why do the paintings take so long to finish?

Howard Hodgkin: Because I find it quite difficult to make up my mind. The reason why they take so long is actually quite simple and I think gradually they are taking less time after all these years. It's

matching what you do physically with the feeling in your mind, or wherever the feeling is, and at long last that is beginning to sort out a little more.

So, you're getting better at it?

Howard Hodgkin: No, I don't think I'm getting better at it . . . no. But a long time ago I thought I would try and make the work in my head and not have so many re-paintings on the wood. And so I sit and invent and then execute.

I had a print publisher years ago, who was really quite savage in a way, but he was sensible. He said printmaking isn't really for someone who is looking for an image, it's for people who know what they've got to say. And I remember feeling very angry and hurt, but he was right of course. I don't think there is anything wrong with endless re-painting, but for me there was always the fear that it would get in the way. What I really want to do is to make my pictures as lucid as possible . . . as straightforward.

Do images come to you more easily now?

Howard Hodgkin: No, I think the images are more difficult now . . . But the physical realization is perhaps a little less illogical than it used to be. I've got to get better at something, after years and years of practice.

I'm not going to ask what they are paintings of, but . . . are you trying to represent feelings?

Howard Hodgkin: Yes, it is that. But the trouble is that I can't really say very much about it . . . because I don't know. What to me is a constant surprise is that people who look at my pictures do seem to realize what they are about in some mysterious way, but I can't explain that.

What do you want people to think? What do you hope they will take away?

Howard Hodgkin: I hope that they will feel what I felt . . . I hope that the picture will get to them in some way . . . and they do, but I can't think why and . . . I can't say why.

Seurat had this wonderful idea where you could have a system of painting – it sounds ridiculous – you had little 'v's and they went up and that meant this was a cheerful painting and then they went the other way and this was a doleful painting, and though it was ridiculous, it does also touch on the fact that people do react to visual things in a way which is very personal to them; it's like they put on this colour shirt and they'll feel like this. I mean the emotions they get from looking at pictures are very sort of *near* them.

Do you hope they'll find some replication of the emotion that you felt at a particular moment?

Howard Hodgkin: They can't, because the pictures are the result of it. In a general sense yes, but they obviously can't go back to the particular private circumstances, and I don't think that matters. If you think of responding to old masters . . . I've always thought what you respond to is the picture and not the narrative. They are simply about human circumstances, and I've never forgotten a moment in America

when I gave a lecture about my pictures, which was really more question and answer, and somebody saying, 'why do your pictures make us laugh and cry?', . . . and I thought, Wonderful. And in the past people often used to smile when they saw my pictures . . . which I thought was a great compliment.

And yet many of them are about intense and sometimes dark feelings, and yet they are also always very beautiful. Is there a contradiction in that?

Howard Hodgkin: No, I don't think so. I wouldn't agree they're always very beautiful, but I think the smile used to be the smile of recognition, like smiling at a person. And I don't think really you can hope for more from a painting than you will touch people in some very human way. This sounds like a recipe for the most appallingly self-centred paintings, and I've been criticized for painting pictures which are completely meaningless. But they're not, and of course the audience would be the first to recognize that if that were true.

But you want them to be beautiful?

Howard Hodgkin: No, absolutely not . . . to me that's one of the great insults – to be told that my paintings are beautiful. I have no desire for them to be beautiful; what would be the point? There are no great paintings that I think are beautiful. I mean they might be beautiful *en passant*, they might be beautiful as a sort of side . . . No , I can't think of any great painting that I really think is beautiful.

I have to say that's the most surprising thing you've said this afternoon. I'm really surprised that you don't think of them as, or want them to be, beautiful.

Howard Hodgkin: I don't want them to be beautiful at all. As soon as they are beautiful, in inverted commas, that is the equivalent of someone saying, 'Oh that's pretty'. It's a complete dismissal.

So, if there is a word that you did *want them to be, do you know what that is? What's the highest form of praise for them?*

Howard Hodgkin: That they're good. I can't think of another one off-hand. That they succeed in getting through to people. But I don't think that has anything to do with beauty. I can think of a lot of very bad pictures which are very beautiful – I'm not going to mention any – and some sort of reasonably OK pictures which are beautiful in a sort of a way. Put it in another way – I do think lots of Degas pictures are beautiful, but we may be using the word in a different way. I think they're beautiful because they are so successful, but my first dealer said to me that his worst term of abuse for a painting that he was buying and selling was, 'Very well painted', or, 'It's beautifully painted', which is actually worse. So maybe we are talking about different things.

I want to ask about colour: it's one of the great things right at the centre of your art. I am curious about how you think about colour.

Howard Hodgkin: Well that's an easy question to answer: I don't. The colours that I use in my paintings are what were necessary at that particular moment. Colour doesn't matter, it really doesn't

matter. The thing about colour is that it has to be functional. David Hockney used to quote Picasso, saying it doesn't really matter which colour you happen to pick up, because one thing leads to another, and supposing I was painting a picture and I'd picked up blue and I thought I'd picked up red; well, the sequence of colours would change completely, but you could make the colour mean what you wanted even though it was a different one. It would just mean that all the other colours would have to change as well. But the colours in my paintings . . . people respond to – I'm having to be very careful here, rather than saying admire – I showed a big new painting to my old friends who know my work very well, and they started talking about some blue in the painting, and I was very pleased by what they said, because it was the emotional connotations of the blue in relation to all the other colours which is what excited them tremendously . . . and that's where the colour comes from. Not from a system.

And the scale of the paintings. They have been getting bigger?

Howard Hodgkin: They're getting bigger and bigger and bigger. I've always wanted to paint big pictures because, as I said years and years ago to someone who asked me about it, when even then my pictures were getting bigger – they're also getting smaller, by the way – is that with a very big picture you can put more in. And perhaps the most important and the most difficult thing about that for me is that once you start painting pictures which are beyond a certain size it changes their relationship with the spectator completely.

For many years I painted pictures which could be seen just like me looking out of the window there. That was that. But once you paint a picture where it's larger than what can be seen with one look and so you have to move across it, it's much harder to control what you are doing. With every picture before this large scale you can have a fixed viewpoint, the painting has a centre, and my pictures, in spite of what many people said about them, are extremely conventionally constructed, and what has sometimes given me courage or confidence to do various, perhaps rather outré things with them is that I know that they have a composition which is absolutely . . . is absolutely firm.

They are like us sitting or standing on the ground and that's because, however much one might not use linear perspective, it works on the assumption that the person is there and you are on the ground like that. Everything relates on one hand to the picture plane and then going behind it to this one thing; if everything is on the picture plane you can move this way or that way. It's much more difficult.

And the frames, which are often so important in physical or painterly terms – they help to provide the grounding?

Howard Hodgkin: Where it particularly helps is because it's got edges. This is what you are working inside, and then it's fun to make them come towards you or to recede. All my pictures use the most old-fashioned ways of making pictorial space, but I still use pictorial space, as do a lot of photographers, particularly as now when they are making huge prints. My pictures in that sense are very ordinary indeed.

Out of the Window, 2000

Conventional – not ordinary?

Howard Hodgkin: They are conventionally ordinary. In one of Sickert's essays years and years ago, he quoted the song 'I Dreamt that I Dwelt in Marble Halls'; he goes on and on about what's in it, and then ends up, I'm not sure how because it's not even a rhyme, 'and a picture to hang on the wall'. That's what I'm saying, I'm painting pictures to hang on the wall. And that is what I'm so unsuccessfully trying to explain about them physically as what is most important. They are pictures to hang on the wall, however big, and they have to be absolutely at right angles to the floor, or otherwise the pictorial space doesn't work

One of my worst experiences was one of my first exhibitions in New York, where seeing all my pictures – by American standards they are not small, they are the size of grains of rice – was seeing all my pictures in a row against the wall, leaning backwards at an angle of 45 degrees. You can imagine

what they all thought – but then the great moment came when they hung one picture on the wall, and they all went, 'Wow, look!' But I'm afraid that is the sort of painter I am.

Could I ask you to look at and talk about one or two specific paintings? One is the early portrait Mr. and Mrs. E.J.P. *I'm curious what you think about your earlier work?*

Howard Hodgkin: It seems to me simply a different means to the same end. It doesn't feel alien to me at all. And the green egg of conversation in the middle of it does exactly what I hoped it would.

When you look at a lot of your work together, are you able to tell which are the good ones and which are not? And does that change?

Howard Hodgkin: Not really, like most people I've painted lots of bad pictures. I don't think they're so bad, they are just not worth looking at. But I'm much more critical about the pictures I'm painting now than when I look back because then it's too late. I can't do anything about it.

You're never tempted to bring them back?

Howard Hodgkin: Yes, but very rarely, almost never, because once a picture's finished then it's finished. You mean bring them back to destroy them?

Bring them back to rework them.

Howard Hodgkin: No, I have I think done that altogether about four or five times in my life, but usually not with success. The trouble with doing that is because of the way I work, when a picture's finished, then it's finished and though it's tempting – if I don't think it's a complete success – to think I can make it better again, because of the way I work from memory, unless I can somehow reimagine the picture I can't really improve it very much. I have done it successfully, but usually with very small pictures.

I wanted to ask about one another picture: Rain. *Can I ask about the circumstances of its painting, where it came from, what the moment was?*

Howard Hodgkin: Now you are asking about the subject: the subject actually is just rain. It was one of the first larger pictures that I ever painted and I was perhaps slightly worried at one moment that it is like a large small painting, an enlarged small painting. It isn't actually that at all . . . but it was a timid leap for me at the time, I was very anxious. I don't mean it's a timid painting, because it isn't at all, but it filled me with fright when I was painting it, and the fright that one gets – or the nervousness I feel – painting large pictures is quite different to the kind of worry you have painting small pictures.

They worry you – do they surprise you? Do you know very clearly where you are going with something or does it come back and surprise you?

Howard Hodgkin: I know very clearly where I am going in terms of the subject and what I want the painting to do, but the painting after that takes over; it has to. The painting has to tell you what to do,

and one has to be able to allow that to happen. But because *Rain* hangs in Tate Britain at the moment I can see whether it has lasted or not and I think it has. When I say lasted I don't mean in terms of artistic . . . I mean . . . whether it's lasted as itself as an expression of the subject . . . and it's lasted quite well.

And Chez Max*, which was hung at Dulwich, and which I thought was absolutely glorious and remarkable . . .*

Howard Hodgkin: *Chez Max* is one of three memorial paintings I painted of the late Max Gordon who designed the Saatchi Gallery in Boundary Road, and who was an extraordinary character. The other two pictures I painted of him were called *In Memory of Max Gordon* and *Memories of Max*, and in some ways I think *Chez Max* is the best, partly because by using this circular format and an antique picture frame, I was able to distance the subject even more from me than I might perhaps have been able to otherwise, and I think it's therefore more intense than the other two.

I do long one day . . . I used not to care about having a retrospective particularly, but now I long to have one so that among other things I could hang the Max Gordon pictures together and . . . I think it's very unlikely to happen but I wish it would. We found a very good place to hang it at Dulwich, I thought.

Chez Max, 1996–97

Are all the paintings autobiographical in a sense?

Howard Hodgkin: Yeah, I suppose they are. Could you say what you mean a little more?

Are they all directly about moments in your life? Does it make sense for you to think of them in any other way?

Howard Hodgkin: I wouldn't be able to paint them then, but I don't think that's so exceptional or strange as it might sound. Most representational paintings are after all about just that. You can't be a representational painter without including yourself, can you? I don't think so.

Finally, what I wanted to worry away at was not what they are paintings of, but what they are trying to do? They are representations of feelings which are very momentary – and people have written and talked about this a lot – are you able to talk about what you're trying to do in terms of making them concrete and lasting?

Howard Hodgkin: That's exactly what I'm trying to do.

Can you try talking that through?

Howard Hodgkin: Well I'll try! Wilfrid Blunt, this extraordinary teacher who I only realized many, many years later was so extraordinary, he taught me when I was about thirteen or fourteen. He taught me about art about which he was very relaxed, much more than his brother ever was. I asked him about his life once and he became very friendly; I don't think he had many people wanting to talk about art particularly, he was a very social person but not in the circumstances of boarding school and so on . . . and I asked him about his life. He said, 'Well, I decided to be a singer and then somebody made a record of me singing and played it to me so I stopped being a singer.'

He'd spent two or three years studying singing in Munich and then he thought he'd be a painter, so he learnt how to do mezzotinting, which is at best a sort of reproductive printing process, and he became quite well known at the Royal College. It's very laborious, mezzotinting. You have a very little thing called a rocker and you have to move it backwards and forwards as it makes the texture, and he said 'I decided to do a self-portrait and it was a self-portrait of me smiling, so I'd go . . .' [Howard Hodgkin grins broadly, and then bends as if to work at a print].

Maybe that's what I'm trying to do! He was trying to make a mezzotint of his smile. Needless to say, he failed.

Do you always fail?

Howard Hodgkin: No . . . I now succeed quite often. That was being silly about Wilfrid, but he then knew he wasn't an artist. I told that story badly . . . he knew immediately that he wasn't an artist so then he tried to teach other people to be artists. He didn't really succeed because he taught them

more to be connoisseurs than artists, but there was nothing wrong with that because it meant you had to look and look and look.

I don't think you can have a successful work of art of any sort which doesn't contain the maximum amount of feeling, but I'm not going to try any harder to define art than that.

So my last question is, why is that important? Why is painting important?

Howard Hodgkin: To me or in the world?

Either or both.

Howard Hodgkin: I suppose it's important to me because it's the only thing I know how to do . . . in so far as I do. In the world I think it's extremely important. I think visual art in the world is of tremendous importance, probably more than it has been for a very long time – all kinds of visual art.

Because?

Howard Hodgkin: Because we need it. I have this notion in my mind of somebody in a room with a window, like here, a room with a window which you can look out of, but then you need things to look at. Things to affect your feelings and your intelligence and your heart – if I can use such an expression. People need that very badly but how do I know? I'm in a way in a complete . . . I'm a lonely person in a studio.

Making things which are companions?

Howard Hodgkin: No, no. Making things which are . . . I'll try to answer your question slightly differently.

Long ago a friend of mine, an artist called Stephen Buckley, was teaching at the Royal College of Art and he asked a student, 'Why are you adding that to the enormous quantity of junk that there is in the world already?' Not a very encouraging question to be asked, but I suppose I have to admit that in the last resort, what I do is not junk and does add something. I can't really think of anything else to say about that.

RACHEL WHITEREAD

I just loved the idea of putting something that was incredibly quiet and calm in this absolutely chaotic city, in the middle of Trafalgar Square. I hate public sculpture, which sort of sounds ridiculous, considering I make it, but I like the way you can almost make something disappear.

BIOGRAPHY

Rachel Whiteread was born in London in 1963. She studied painting at Brighton Polytechnic from 1982 to 1985 before moving on to study sculpture at the Slade School of Fine Art, London, until 1987.

Since the late 1980s, Whiteread has created a unique body of work that has been widely exhibited and internationally acclaimed. Her important group shows include the 9th Biennale of Sydney in 1992, and she was shortlisted for the Turner Prize in 1992, which she won in 1993. Whiteread's first solo show in Britain was at Tate Liverpool in 1996. She became the first woman to represent Britain with a solo show at the Venice Biennale in 1997, for which she was awarded a medal.

Rachel Whiteread's work is produced using traditional casting techniques. She has created some of the most remarkable and resonant public sculptures of recent years, culminating in the making of *House* (now demolished), which cast in concrete the interior of a terraced house in an abandoned architectural space of London's East End.

She also frequently works on a domestic scale, using discarded household items and casting in plaster and resin the spaces inside, around and beneath furniture, floors and staircases. One of her best known works, *Monument*, established a shimmering presence after it was installed on the empty fourth plinth in London's Trafalgar Square during 2001. Her art is a uniquely poetic response to the everyday, and to the haunting themes of memory and mortality.

Rachel Whiteread lives and works in London and is represented by the Anthony d'Offay Gallery. She was interviewed at her studio in January 2002.

RACHEL WHITEREAD

How did you become interested in the casting process?

Rachel Whiteread: As a student in Brighton I started as a painter, but gradually I moved on to sculpture, and I did my postgraduate at the Slade in sculpture. I wanted to learn how to use tools and equipment in workshops, which as a painter I hadn't really done. The artist Richard Wilson had come to run a foundry course for a couple of days at Brighton, which is how I first became interested in the casting process, and I've been working with that ever since then, which was about fifteen or sixteen years ago.

I think I've always worked in a way that's been taking it step by step. It's essentially been a linear thought process that has been illustrated by sculpture. I think as my language has developed, and as my thoughts have developed, that has changed. And obviously now I have a much larger vocabulary that I can work with, which is actually more daunting in a way. You get many more choices so you have to spend a long time scratching your head before you finally make a choice. Whereas I think initially it was very much a process of enjoying new materials, working out how to work with colour, form, and how to make something sit on the floor or lean against a wall. Now I have all this information.

What were your first experiments with casts?

Rachel Whiteread: The very first cast that I made was when I realized that you could really change something by using a very simple process. I'd pressed a spoon into sand and then poured some lead into it, and it lost the spoon-ness of the spoon. The hollow of the spoon had gone, and it had become flat and you had this little sort of lip around the side. It had completely changed it. From one side, it still looked like a spoon. From the other side, it looked like something entirely different. And I just fell in love with that process.

When I was at the Slade, I'd been thinking about childhood memories, and a lot of the work was quite autobiographical. I had got this wardrobe, which was very similar to a wardrobe that I'd known as a child. I wanted to somehow make this memory concrete of sitting inside wardrobes. I remembered doing that, sitting amongst my parents' clothes, and looking through the cracks in the doors. You'd see chinks of light. There was a kind of black furry space, and I wanted to make that solid. So I simply got this wardrobe, filled it with plaster, closed the doors, and waited for the plaster to cure. I opened them, took off the sort of carcass of the wardrobe, and covered it in black felt. I'd finally made something you could walk around. It was a three-dimensional object that had human dimensions. It was a complete revelation. It really did feel like the first thing I'd finally been able to make after six years as an art student that finally pulled it all together. That was the first piece that I made, and then I made a series of other works, which were all based on what you'd find in a domestic room.

Opposite *Water Tower*, 1998

Untitled (Torso), 1992–95

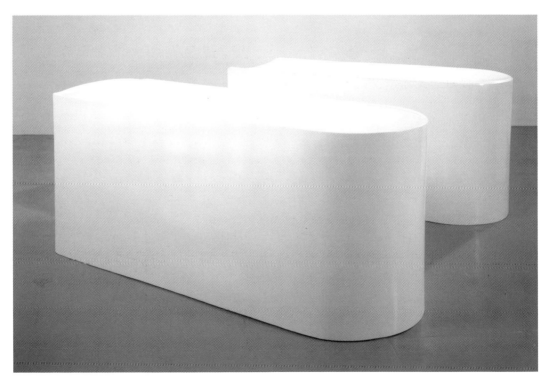

Untitled (Pair), 1999

What did you first exhibit using casts and what was that work about?

Rachel Whiteread: The first show that I made had a piece called *Shallow Breath*, which was a cast of the space underneath a bed; *Mantle*, which was the cast of a dressing table; and *Torso*, which was the cast of the inside of a hot water bottle. These were the elements of things that I thought about as being part of either a small bedroom or . . . really, I think, for me, it was about leaving home, leaving my family home and going off to college, and staying in these crappy houses with other students. So that was my sort of sketchbook, along with London and the junk shops around London which I would have a good rummage in.

So, that's where it started. And then I made *Ghost*, which was again thinking about my family home. I think I was just trying to find a way of looking at the domestic in terms of relationships, and the relationships that people have with their homes and their furniture. It was trying to bring all those things together and, I think, quietly talking about maybe some of the darker things.

Was this work also about death?

Rachel Whiteread: I don't think that using forms that are related to death is something that I find sinister, and yet people think that I'm obsessed with death, which I'm not. I don't think it's sinister. I think there's a very strange denial of death, especially in this country, and people don't quite know how to deal with it. People don't really understand it. People hide. It's not a celebration of people's lives. It is a terrible tragedy when someone dies, but I think it's also that people have lived their lives and things are left behind. Memories are left behind. I think because my father died and had been ill for some time when I was relatively young, I had thought about these things very carefully. They profoundly affected me and I am still affected by them.

How did Amber Bed *come about?*

Rachel Whiteread: *Amber Bed*, which is the cast of the underside of a bed made in rubber, came out of having made a lot of work in plaster. I was showing a lot around that time, and I was getting increasingly frustrated with things getting broken and bits getting knocked off. I wanted to make something out of a different kind of material so I could literally bounce it around the studio and it wasn't going to get damaged. I made this cast, which was similar to *Shallow Breath*, and then I didn't quite know what to do with it. It was very heavy, and I was shifting it around the studio, and I plonked it against the wall. It did this amazing thing, where it just sort of took on the shape of the wall and sat there, slumped, looking like a body. Every time I turned round I would get a shock, thinking it was someone sitting in the corner of the studio. Of course it started making me think about derelict people. It started making me think about the homeless. It started making me think about Hackney, and mattresses that were left everywhere and still are left everywhere. I was using mattresses and beds for all sorts of reasons. But as you work with these things, and with this material that people have slept on and people have died on, then inevitably it has this whole history and resonance which becomes part of the work.

RACHEL WHITEREAD

Can you talk further about Ghost?

Rachel Whiteread: I had this idea that I wanted to mummify the sense of silence in a room, the air in a room. I didn't really know how. I didn't really know what it was going to look like. It was almost slightly naive. I just thought, well, I want to make this thing so I'll just try and see what happens.

I found this house in Archway, which I was delighted with, because it was close to where I lived as a child. The room was the right sort of size, and I remember that there were certain elements that I needed in the room, like a window and cornicing. I wanted a fireplace and a skirting board, a door and a light switch. I spent weeks in there, deciding how it was going to be made, how it was going to be cast, and what size the blocks were going to be. I was thinking at the time about Piero della Francesca's paintings. I was thinking about proportion.

This process went on for about three months, and I then dismantled it and reassembled it in my studio in the East End. Soon after I came into the studio on a really beautiful sunny morning. I saw the light switch, and the light switch was back to front. And I just thought, 'Oh, what have I made?' You know, I'm the wall. And it hadn't occurred to me at all before, being involved with the practicalities was all consuming. It was a moving moment for me, quite a revelation. I called it *Ghost*.

How did House *come to be made?*

Rachel Whiteread: *House* was obviously a piece that I'm incredibly proud of. I think it's a real achievement to have made it. It's one of those things that I went into that was, again, in a way quite naive, I think. I just thought, 'Well, let's try and do this.' And we did it. It took an awfully long time, and it was a massive headache. But it ended up with this quite extraordinary sculpture, which touched people on many different levels, whether they were interested in art or whether they were interested in politics, or whether they were interested in road building.

House was very simply the cast of the inside of a house in concrete. It was a turn-of-the-century terraced house. I chose that particular terraced house because it represented an archetypal house with its typical architectural style. I literally built a building-within-a-building.

We laid the foundations and then put on a layer of white concrete. After that we tied in a metal structure which held the next layer of concrete, which was like a heavy fill of darker concrete on top. This all set and then we literally took the building off from around the piece.

I think *House* had a mausoleum quality, but I also think it was a little like a fossil, or something that had been excavated. It had this very strong but slightly fragile presence because the actual width of the piece was only about fourteen foot.

The depth was far greater, which drew one's attention to the very narrow living spaces that we normally inhabit. Once the two buildings were cleared from either side of it, there was this rather strange building just standing on its own in the middle of a park.

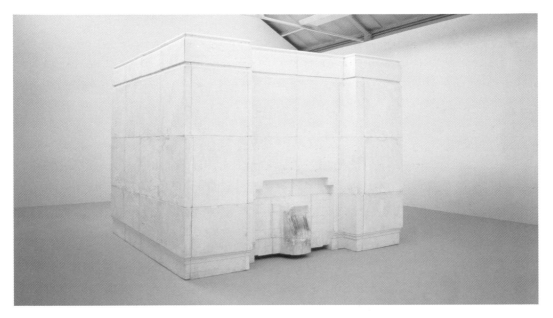

Ghost, 1990

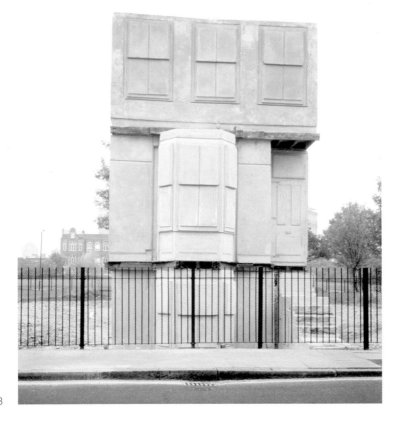

*Untitled
(House)*, 1993

RACHEL WHITEREAD

House *was of course demolished after only three months. What are your feelings about that now?*

Rachel Whiteread: I thought *House* would be controversial, but I hadn't realized it would cause such a stink. It really moved people. The main regret that I have is that I don't feel that I ever really got to see it. It nearly killed me making it. I actually became quite ill with all the stress of making it. It was totally overwhelming. Immediately afterwards, there was the media flourish, the attack, the Turner Prize, and all sorts of other things that happened. I think I found it a real strain. I would go and see the piece, but sort of go in disguise and sit in the car, with a hat and sunglasses just trying to figure it out, watching people watching it. There were petitions to try and keep it up. Everything you can possibly imagine went on. And then it was knocked down.

Councillor Flounders was the guy who was virtually solely responsible for doing it. He was obsessed with getting rid of this thing. It's a shame, I think, that it didn't have a chance to become invisible, in the way that architecture becomes invisible. I think that's an interesting idea and maybe it's something that I will work with at some point, though it's not what this piece was about.

House had this brief fight for life, and now the place it inhabited is a park with closed gates, and people throw their dogs over the fence to have a shit in there. That's sort of what the place is now. It really is ridiculous, and there are probably very few countries in the world that would do that to an artwork that had been such a success in many ways. But we managed to do it. It taught me how to become tougher about, not what I do – because I've always been very tough about what I do – but dealing with the consequences of what I do.

How did the Holocaust Memorial *in Vienna come about?*

Rachel Whiteread: The Memorial in Vienna took five and a half years to make, and I spent two and a half years really fighting to make it happen. And then I said, 'Sod you, you know, sort it out yourselves. There's really a big problem here. I'm not from Vienna, I'm not from Austria.' I knew what was going on, and I understood the politics and I understood that the whole thing was really very tricky, but I didn't quite understand the machinations of the political situation over there. It's extraordinary, incredibly bureaucratic, and also quite provincial. The whole situation became very difficult to deal with.

When I was asked to put in a proposal for the Holocaust Memorial, which was actually quite soon after *House*, I was quite reluctant, but then I started to think about it. It felt like a challenge to try and make something that was both poetic and aggressive about the Holocaust – something that was quite upfront and non-figurative.

I came up with the proposal and it was for a very specific place in the historical centre of Vienna in a medieval square called Judenplatz, which was where the Jewish quarter had been and where there had originally been a synagogue, which was razed to the ground in the fourteenth century. Eventually, after five and a half years, we now have in the square my Memorial, some excavations and a Jewish history museum. It's a unique and extraordinary place, it works incredibly well.

RACHEL WHITEREAD

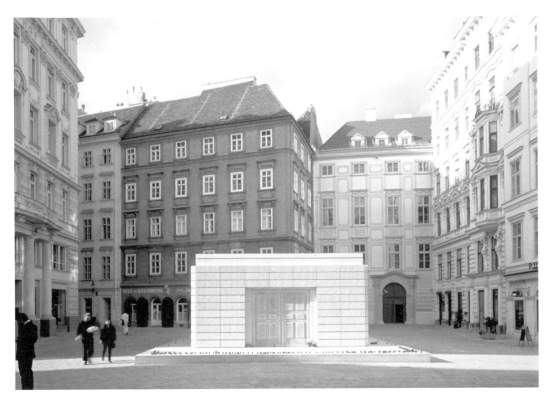

Holocaust Memorial, 2000

One of the main problems during the building of the piece was essentially the politics that go on in Austria. There is quite a right-wing situation over there. During the time that we were making the piece, the government changed three or four times, so there were elections going on continually, which also made it very problematic.

The Memorial was really about being on the outside of something and looking in. I think that was partly because I'm not Jewish and yet I felt that I was dealing with a subject that I'd always known. I hadn't had real involvement but friends of my family had been in concentration camps. As a child, I knew of people and I knew of people's history and of dreadful things they had endured. I was, I think, profoundly affected by that in some way.

I lived in Berlin in 1992 and 1993 for a year or so. When I was there, one of the things that really fascinated me was people watching – watching people who would have been my grandparents' age. You just look at them and think, 'What did you do? Where were you during this time?' And, you know, 'Where are you from?' Not wanting to blame anybody, but it was just something that I got a bit obsessed with. I did a lot of reading when I was living there, and I went to a lot of concentration camps. This was before I'd been asked to make this proposal.

So I'd been thinking about all of these things, and I was trying to work out a way of bringing it all together. I knew about Austria's history, and I wanted to be quite brutal about it. I didn't want to be involved with simply putting a Band-aid on the situation. The Austrians are not really very good at saying sorry and to some extent they are in denial about what happened.

I wanted to make this point, but I had to do it very carefully, because obviously I couldn't let them know that I was trying to make this point. I wanted to make something quite brutal. As a library, using the books and turning the spines of the books on the inside, you had no sense of what was written in the books. It could have been a list of names, it could have been Jewish history, it could have been whatever you wanted it to be.

I made this bunker-like structure with these blank books, and two doors that you can't open that have two little holes where the doorknobs are, which are the only way that you feel you could get into the piece. There's no light switch, no electricity plugs, no way in, no light – there's nothing. It's just this blank space.

I'm very glad it's over with and I'm very relieved. I'm now finally very, very proud to have made it.

What brought about your fascination with staircases?

Rachel Whiteread: When I made *House*, the one thing that frustrated me was the staircase. When you went inside *House*, because it was obviously made from the inside, we had to cut the staircase in half – well, we didn't actually cut it, about a third of it was left attached to the wall and we cast around it. It really felt like I'd cheated. It always irritated me that somehow I hadn't managed to either pull out the wood where the stairs were or somehow make it more complete. No one else knew this apart from me. It's purely my own neurosis. It had always niggled me, and this was in 1993.

I didn't quite know how to focus that form. It's incredibly difficult to look at a staircase and imagine it as a series of blocks, as a space filled with air, and to mummify the air, because there isn't really a beginning or an end. Every single staircase is different.

I became very intrigued with the notion of how to try and make these things concrete and then how, by turning them upside down, or just by moving them slightly, you could completely disorientate the viewer. This is what I tried to do with a piece that was recently shown at The Serpentine.

I think it's up to the person who's looking at the work to figure that out for themselves. Whether or not they decide to be excited about form, colour, texture, or whether they are analysing the history of the staircase, or analysing architecture, or whatever it is that people choose to use as their key to get into the work – I'm happy for them to do that.

Opposite *Untitled (Upstairs)*, 2001

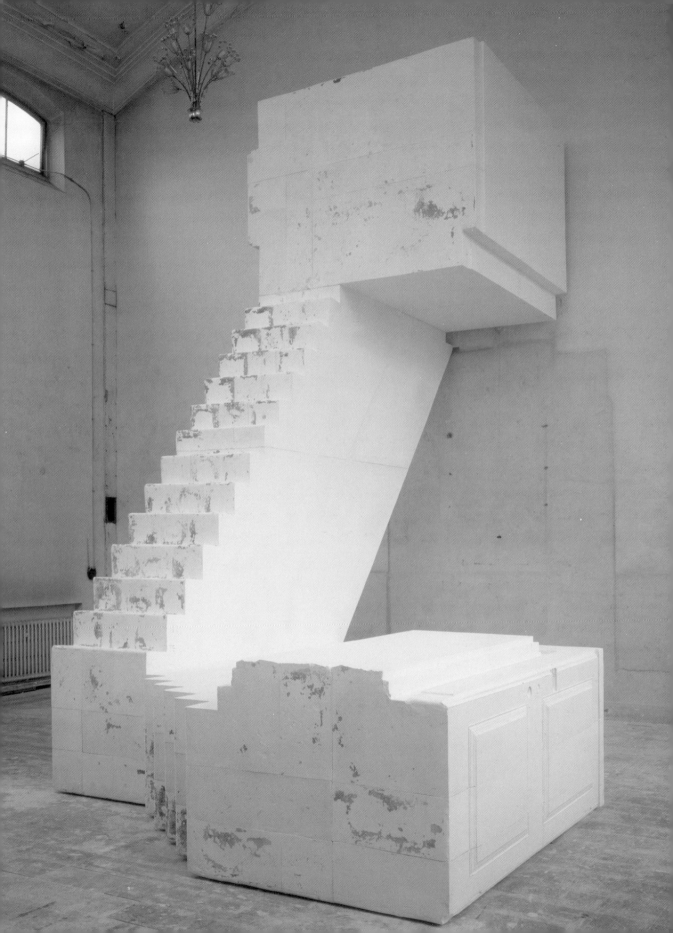

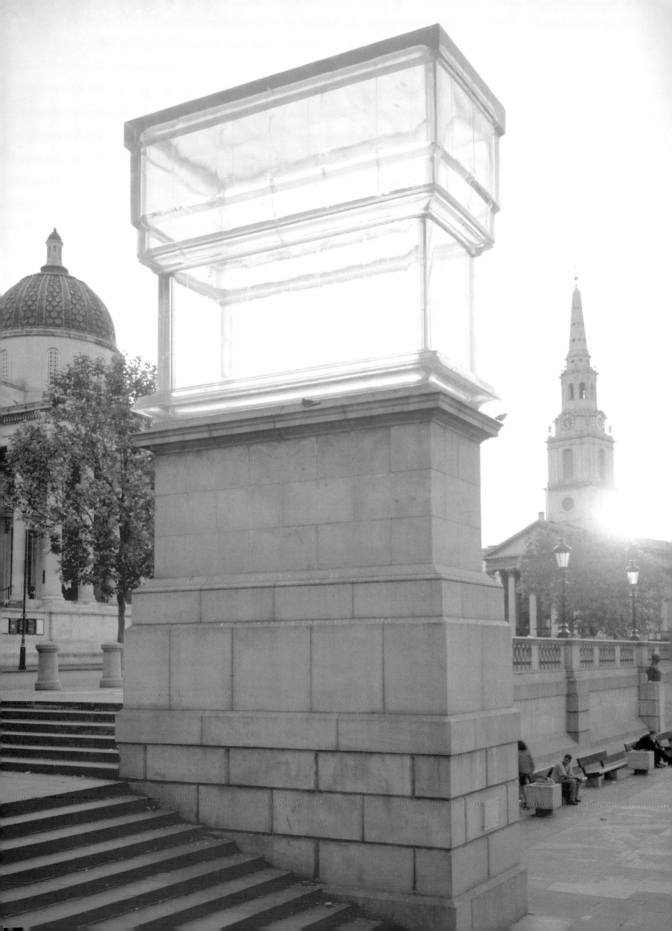

What were you aiming to achieve with the piece Monument *in Trafalgar Square?*

Rachel Whiteread: I'd been asked to put in a proposal for the plinth in Trafalgar Square. Initially I thought this was a crazy idea, and then I spent the day in Trafalgar Square, and looked at the plinth. It really is a very beautiful piece of architecture, and I decided that I wanted to put in a proposal for it. In retrospect, this was probably quite stupid, because it took an awful lot of research and an awfully long time to make.

I came up with the notion of just simply having the plinth, making a cast of it, making it in a clear resin and inverting it upon itself, so you just had a sort of reflection of itself. It sounds very simple, and, as all simple ideas are, they tend to take forever to make. I spent literally about four years trying to work out how to make it and put it up there.

I just loved the idea of putting something that was incredibly quiet and calm in this absolutely chaotic city, in the middle of Trafalgar Square. I hate public sculpture, which sort of sounds ridiculous, considering I make it, but I've often tried to make something that is almost invisible.

The way the press dealt with it, calling it a Glacier Mint or whatever, is what you would expect. But I also think it was a very serious piece of sculpture. I wanted to try and make something in a situation like that, something that would almost disappear, that you could ultimately ignore if you wanted to, in the way Nelson's Column in Trafalgar Square is sort of ignored. It's the most ridiculous folly but it's an amazing thing as well, but people don't even really see it any more. It's just there.

I tried to work with those things, with the traffic, the buses, the National Gallery, the fountains and all of these elements to make something incredibly quiet that sat there with some sort of dignity. Hopefully, I achieved it.

Opposite *Monument*, 2001

JULIAN OPIE

*I often feel that trying to make something realistic is the
one criteria I can feel fairly sure of. Another useful one I
sometimes use is, 'would I like to have it in my room?' . . .
I occasionally use the idea: if God allowed you to show
him one thing to judge you by, would this really be it?*

BIOGRAPHY

Julian Opie was born in London in 1958. He studied at Goldsmiths' College between 1979 and 1982 and his first solo show opened at the Lisson Gallery, London, in 1983. Celebrated as the youngest of the 'New British Sculptors' at the height of their success in the early 1980s, he subsequently diversified to encompass a variety of media from video and vinyl to scaffolding wrap.

Since then Opie has exhibited widely in Europe, Japan and the United States. In 1995 he was awarded the Sargant Fellowship at the British School in Rome before taking up a year-long residency at the Atelier Calder in Saché, France.

In 2001, he had one-person shows at both the Lisson Gallery and at the Ikon Gallery, Birmingham. The flimsy mail-order style Lisson catalogue playfully explored the flexibility of his work for consumer purchase: paintings on wood, prints, computer films, wallpaper, signs, concrete casts, all available in various formats and dimensions, complete with price lists.

Opie has a long-standing interest in non-gallery locations for his work. His CD cover for the Blur album in 2000, based on his portraits of the four band members, also involved billboards, bus posters, T-shirts and mugs. Other non-art locations for his work include Terminal 1 at Heathrow and Wormwood Scrubs Prison in London.

Opie's highly distinctive depictions of the modern world, seen in his bold portraits, subtle landscapes, unconventional wallpaper, playful sculptures of animals, buildings, cars and computer films, present simplified and iconic versions of the contemporary environment.

Julian Opie lives and works in London and is represented by the Lisson Gallery. He was interviewed at his studio in October 2001.

JULIAN OPIE

How important is it to you that your work is accessible and popular?

Julian Opie: I tend to make both works and particularly exhibitions very much in terms of imagining somebody's response to them. I don't want to make a piece of work that's like a secret cupboard that no one ever thought would be open, but you have got to open it. What I want is a sense that the viewer, whoever that is, is part of a triangle, and that their response completes the work. I think that often the way critics look at a show is very literal and literary, whereas ordinary people seem to be more relaxed and associative in the way they relate to the work.

Is your recent work realistic? Would that be the right word to describe it?

Julian Opie: I often feel that trying to make something realistic is the one criteria I can feel fairly sure of. Another useful one I sometimes use is 'would I like to have it in my room? Would I like to actually sit and look at it?' I occasionally use the idea: if God allowed you to show him one thing to judge you by, would this really be it?

But overall, I think a notion of how to make something realistic is a key factor behind most of the works. I go through different phases of how I think it's possible to make something realistic. It strikes me as interesting that an immediate notion of realistic would be highly photographic. I think things move that way, bit by bit, towards being something like photographic. That was clearly true of the early Renaissance through to the late Renaissance. It's true of early computer games through to more recent versions, and so on. What I find is that I'll make something more and more complicated and detailed, but I can also work back the other way and suddenly find I can knock a lot of that out, and that can make it more realistic.

What does realistic mean? It means something that tallies with my, or your, experience of the world and that is, I think, not always photographic at all. I find most of my work comes from a sense of excitement on my part, or being intrigued by things that I see in the world. It's really about noticing things and thinking I could use them, I could bring that into my language and my discussion. Often in life things are fortuitous if you keep poking away at them. So [at the Ikon Gallery] in Birmingham, for example, the building opposite the lift shaft has a similar window pattern to the one that I've put on the lift shaft. It's then easy to think that I did that on purpose – and nice. I try to make the work function in a way so that will happen. When we're talking about realism we're also talking about memory to some degree, so it's realism that is held as information in your head.

There's a sense of realism in your work, but there's also a sense of naiveté*, of childishness. How much of it is a kid's world?*

Julian Opie: A big seam of usable material for me has come from toys and children's models. Well, not even children's – just models altogether. Renaissance architectural models of buildings are

Opposite *Tower*, 2001

fantastic. I've looked at them and used them in a way that has been quite inspiring for me. I've made wooden buildings on a similar scale. They're both too big to be toys and too small to be liveable in. I also take a lot from graveyards where you find the world reflected and modelled on another scale in another material for the dead.

For children, the world is again rescaled, redrawn, to make it into a usable language, and it therefore becomes very usable for me, both in its raw sense but also in its associative sense.

I know that I can key into other people's experience of those things. They'll recognize what I'm using and know what references I'm talking about. It's not only about what's recognizable but also perhaps about what's desirable. I think for children it holds the desire of what they want, and for grown-ups it holds the desire of what they've lost – a feeling of a world that was more controllable.

I play this off against that which is not controllable. So for instance, there's a work in Birmingham at the moment where some quite cute and friendly animals are depicted on tough, hard, urban sign posts. My aim really, in mixing these two languages, was to get at this feeling of duality, I think – of how you can feel out on the street excited to be in London and very aware of yourself as being alive and being part of what's going on, whilst on the other hand you can also feel threatened. To try and capture these two elements is quite important to me – to be realistic.

There's a kind of recognizable Opie-world that has a certain coherence, and I wonder whether that world is a kind of utopia that we want to live in or go back to, or is it a sort of threatening dystopia?

Julian Opie: I am not at all keen to create an Opie-world. I enjoy going to other worlds like Legoland or EuroDisney for their attempt to create worlds, and I enjoy computer games for their attempts – and very often for their failures, where it doesn't work.

What I'm more interested in doing is somehow reflecting on the existing world and thinking about it – looking at it and making my version. Is it my version of it or a version of a realistic image of it? I think describing what it feels like to be there perhaps would be one way of putting it.

I saw something in the world that I thought looked great and worked really well. In an airport there were some little LEDs with a rolling arrow that tell you to go onto the escalator-walk type of thing, and there was something about that flashing little movement that animated so much space around it, even though it was so small. It made me think of putting these flashing lights into the pictures. It was a search for greater realism really that made me want to. I recognize that in a certain sense there's a patheticness about that.

In the same way I'm putting a soundtrack to a landscape painting that I'm playing with – with the picture on two levels. I want to make it engaging. If you try and play a computer game with the sound off you realize how unengaging it is. You need the sound on. If you try and turn the sound off on the TV it's just nothing really. On the one hand I think that the sound of a passing aeroplane will literally animate the scene that you're looking at, but on the other hand, as an object you've got this rather

Whiteread: *Untitled (Amber Slab)*, 1991

Whiteread: *Untitled (Novels)*, 1999

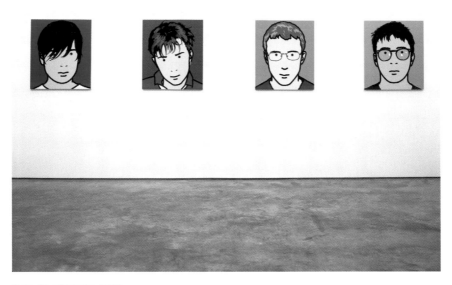

Opie: *Blur Portraits*, 2000

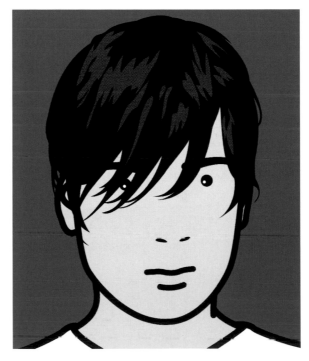

Opie: *Alex, bassist*, 2000

Opie: *My aunt's sheep*, 1997

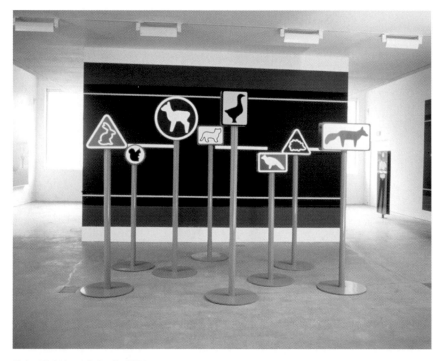

Opie: *Eight Lost Animals*, 2001

Opie: *Wind Planes Silence*, 2001

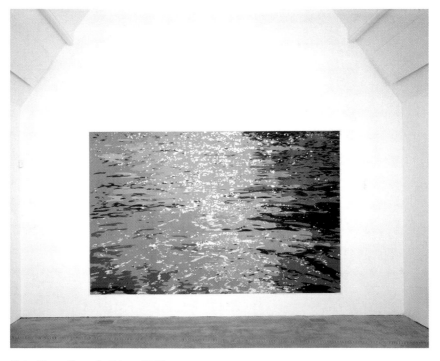

Opie: *Waves Seagulls Voices*, 2000

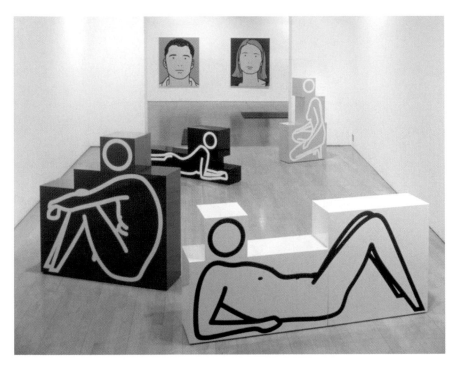

Opie: Installation view *Sculpture Films Paintings*, 2001

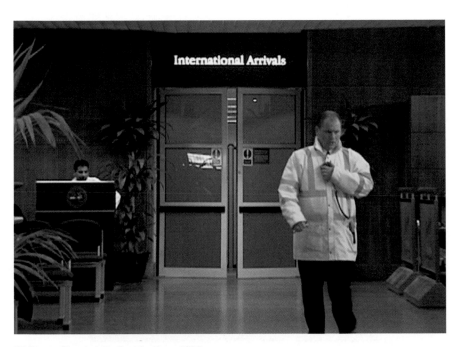

Wallinger: *Threshold to the Kingdom*, 2000

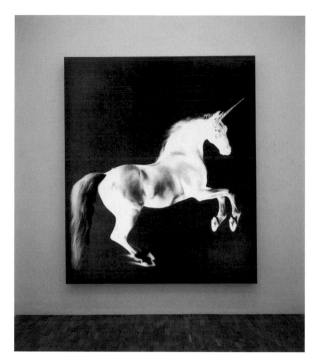

Wallinger: *Ghost*, 2001

Wallinger: *Ecce Homo*, 1999

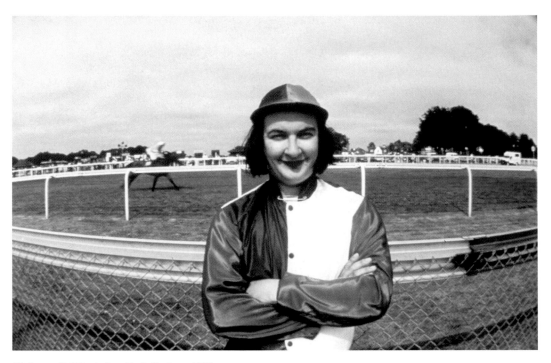

Wallinger: *Self Portrait as Emily Davison*, 1993

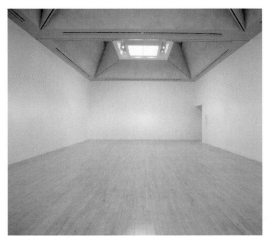

Creed: *Work No. 227: The lights going on and off*, 2000

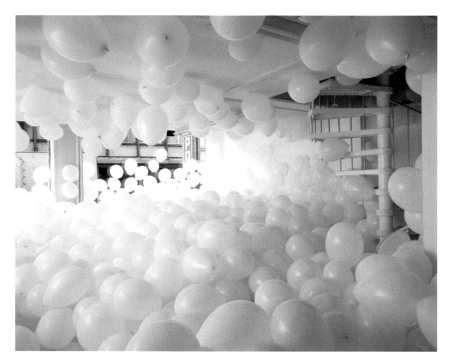

Creed: *Work No. 200: Half the air in a given space*, 1998

Creed: *Work No. 79: Some Blu–Tack kneaded, rolled into a ball, and depressed against a wall,* 1993

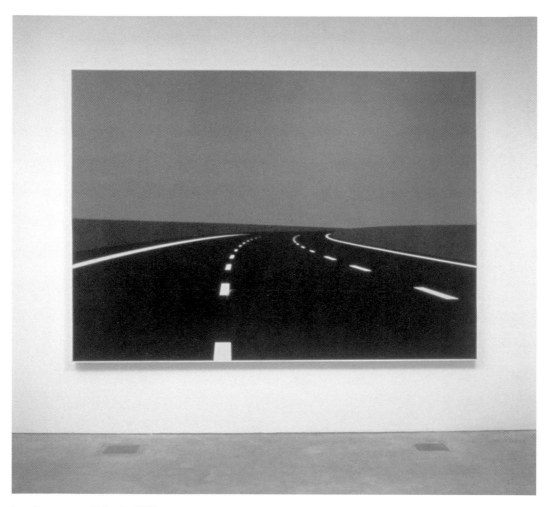

Imagine you are driving 2, 1990

clunky light-box thing with a Perspex covered image that's very glitzy and glossy with sound coming out of it. There's a lot of technological effort apparently being put into it, but it's a very blank landscape and it's also quite a blank sound.

What I'm saying is – here is an image of nowhere with nothing happening in it, but I'm going to a great deal of effort to animate this for you. I'm doing that seriously because I want to recreate some sense of quietness, a sense of presence, a sense of just being. I think an empty space can do that more than one where there's lots going on. If there was a dog being killed in the middle of the picture, that would obviously become the subject. You wouldn't think about anything else. But the fact that they're all empty, except, perhaps, for a plane taking off, or a little light blinking on the horizon, somehow brings the moment into the present for the viewer, I think. Hence the realism.

JULIAN OPIE

I vividly remember your work with painted metal sculpture from nearly twenty years ago. Can you reflect on that work and your work today – are there similarities, or can you describe the distance that you feel you've travelled from then until now?

Julian Opie: I spent a lot of energy trying to convince other people and myself that there is a thread and a connection through the work. I remember my gallerist saying that I was going to have to carry on doing that until people stopped asking. And I guess I did – but I think the one thing that does happen is at the point at which your work becomes of interest to other people, which is a key moment. You have a very odd relationship with it. I gave it an awful lot of attention. I think that I did focus very much on that part of the work so that when I finally decided I couldn't and didn't want to carry on making it any more, the jump was rather large and quite shocking to me. It was quite painful and difficult for other people to follow as well.

The work that I did and first became known for was in many ways very similar to what I do now, but in many ways it's the work of someone who is twenty years younger than I am, and it's very handmade. It's very obviously handmade and has a very different feel. In that sense it has a very different quality, but in a kind of sense of image on boxes, of reusing symbols and images from around us, putting them together and making my own pictures out of them, referring to art history and the way that art history has been used and represented – all of those things are still there. I did spend time making things, both in terms of metal, wood and paint and so on, and I'm not against that, if it's the best and quickest way to do something.

There's no point now at which anything like the artist's hand, or mark, comes into it at all. There's no making or working with materials. You're working entirely in a digital environment. You're then ordering somebody to make it or output it. You're not doing anything. Is that a problem in any way?

Julian Opie: What I find at the moment is that other people can do them perfectly well and it frees me up and allows me a position further back which is more like the puppeteer. I'm in control and I enjoy that position much more. Spending my entire day peeling off masking tape is OK but I'd much rather spend the day drawing some other ideas or other possibilities. Having said that, I'm not so sure that peeling off masking tape or brushing on the paint is any more authentic than making a series of telephone calls.

What I do is I control very carefully every element and aspect of what it is that I want to make. The fact that I'm doing it on the computer doesn't mean that it's hands off. Physically my hands don't touch that material that you are standing in front of. They might – they might not. They might if I washed it, which I often do, but they don't in terms of putting the plastic sheet on. That's a process that can be managed. But I have pored over it for many hours. Does that make it better than something that I've pored over for a few minutes? Not by definition, though I think poring over is for me the way in which I work, and it shows. My mum occasionally says, 'It looks like you rushed it', and you know she may be right.

JULIAN OPIE

To tie in with what I was talking about before, I often read that people will say what I do is computer-generated art, and I think there's a misunderstanding there. There's an idea that there might be a program available. In fact, someone approached me in order to try and make one that would make artworks. Although it's easy to say that's rubbish – and it clearly is rubbish – one shouldn't forget that Renaissance paintings were made by workshops, and there was no way that anybody could undertake huge tapestries and so on by themselves. Throughout the ages artists have used the best thing that's around in order to make the work that they want to make. Hanging onto the last generation's version of that would seem pointless if you're just doing it for its own sake. The point is to find what works for you, which may well be, for example, layers of glazes on canvas. That can work excellently, and it's a brilliant way of making images. It's very portable, doesn't cost that much, and is very beautiful. But it's not right for everyone.

Can you talk about the role the computer plays in your work, about the process of input?

Julian Opie: I was drawing buildings a lot. They changed the way that I made things because modern buildings are very often rectangular. The object on which I painted the building was itself rectangular, which at a push became quite like a painting. I mean it stood on the floor so it had to be a bit thicker. At that point it occurred to me that I didn't really need to always make the object that I was drawing. I could just have this box and I could put anything on it. It was around the time that I had a child and I saw that children's toys often do that. You just need a little box. If you paint a tree or a car on the side of it, it becomes a tree or a car for the child.

This suddenly opened up a lot of possibilities for me. I could draw things that I couldn't make. So I could draw sheep – I couldn't have made a sheep really with my technology and that was a short step therefore to drawing people, which I'd never expected or wanted to do really.

For people, I consciously looked around for a way in which I could draw them. It started by buying from a hardware store the aluminium symbols for male and female toilets. I looked at them and thought, well, if I can combine, as I often do, the impersonal with the personal . . . So I photographed my then-girlfriend. Looking at these male and female symbols I tried to draw over the photograph. Actually I have a computer and at this stage any kind of graphic work, any translating, any reproducing, any tracing is so much easier on a computer than any of that old stuff that you needed to use like tracing paper and Letraset.

I found that taking a digital photograph, in a way, is the equivalent to standing the person in front of a sheet of glass, and with one eye shut and your arm outstretched, you draw around them, which is what people used to do in one form or another. But by using a digital camera I can take a photograph of someone in Osaka, come back to my studio, put the digital photograph into the computer and then work on it. What I like about the computer is that you can work on it again and again. You can get it just how you want it. I like to control things. I can see the enjoyment of letting go a bit, but given the choice I'd rather be in control.

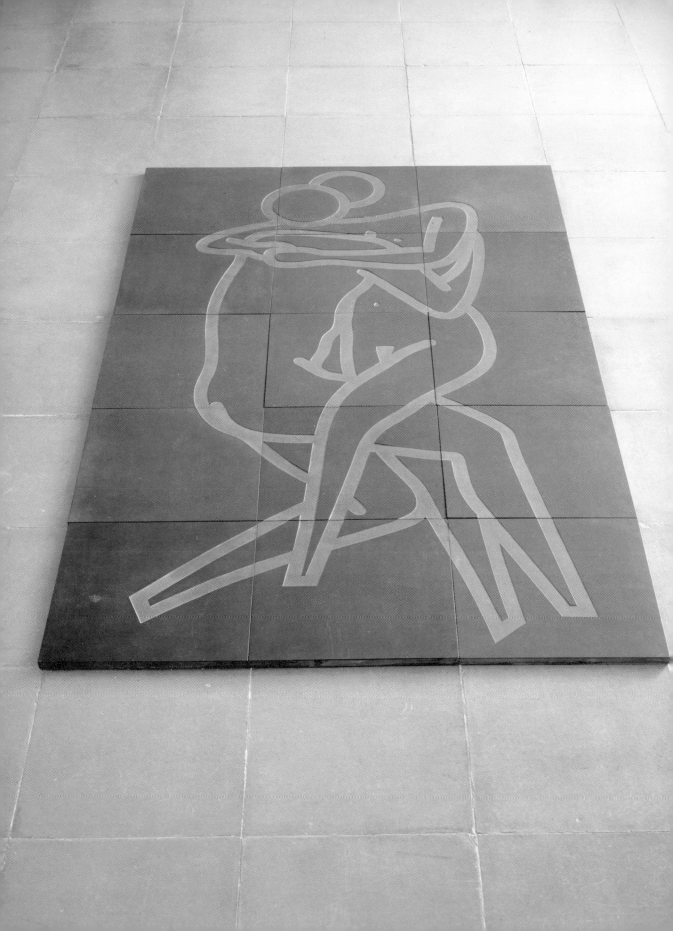

JULIAN OPIE

What is your process for drawing faces?

Julian Opie: What I actually tend to do is to import the photograph of whoever I'm going to draw into the file that's already got somebody else drawn in it. I'll usually pick another family member, if I'm drawing a family, as often seems to happen, or someone who looks a bit like them, perhaps another child.

I'll start with the standard line thickness. I draw with a very thin yellow line, which I can see on top of the face. And then I draw with this thin line. I draw the line that goes in between the lips, but I don't go right out to the edge. I stop at about the point where the lips are really finishing and becoming the face, which is difficult to know often. It can mean that the little smile that comes at the very edges doesn't get into my pictures. At a certain point, there's a setting on the computer that can turn that yellow line black, and then can make it thicker and can decide whether the ends of that line are curved, or straight and square. All of these are decisions that I've built up over the last few years. It's almost like natural selection. I've built up these rules. Once I've got the basics of the face in, and

Above *Alex, bassist*, 2000
Opposite *Remember them 1*, 2001

whatever is being worn, then I feel very pleased with myself. I usually think this is amazing. Within an hour I've got a portrait, a new person, a character in my menagerie, and it's very exciting. If the look isn't quite right, I'll work on it for a few hours longer. Sometimes it's never going to work. But mostly I just battle on.

The most trouble I have is with the chin line, which is hard to get right. It's not actually the edge of the face on the photograph, it's something else. A photograph only tells you so much. Where does a chin begin and where does a neck end? I've made some rules so the eyes are not actually a drawing of the iris. They're a drawing of the bit of the iris that you can see. So if you've got someone who actually goes round looking like that, I'll only draw them a very small circle even though they may have a big iris in fact. I'll sometimes cheat too. For children I'll sometimes expand the visible iris.

Finally, at a certain point I'll drop the photograph with relief and then I've just got the portrait. At that stage it's a matter of deciding how to crop it. I think the cropping is to do with maximizing everything about it, about the person, holding on to the hair, and the defining elements of their clothes and necks, but at the same time making it look like a portrait. That's quite important to me. Sometimes people say, couldn't you draw the whole family in one picture? I've tried. It just doesn't seem to look like anything. Whereas this little thin box, with a person's face filling it, seems to be more than just a face. It becomes an object, it becomes a thing.

There's then an issue about colours. I've gone through a number of phases of wanting really bright screaming colours, to wanting bluey, greyish greens. I've been through pastel phases, and at the moment I'm quite into kind of auberginey colours. I'm also beginning to build up more and more rules, which worries me a bit. Blondes work well with blues. People with black hair work well with bruised cloudy types of colours. Sexy looking people work well with green. As those rules build up you become more and more hemmed in. What I've found in the past is that there's a point at which there are too many rules and I can't function any more.

I'm doing a few people at the moment and I still find each face quite an exciting challenge. There's something very particular about drawing humans which is different from buildings and cars. I'm enjoying the fact that I meet these people and sometimes I know them, and that they become enmeshed in the process.

Tell the story of the Blur cover in relation to it being a CD cover, which is now four paintings on the wall of the National Portrait Gallery. How are they different?

Julian Opie: I did a show near Hoxton in a small gallery. Bob Shuckman, from the pop band St Etienne, saw it and liked it. He asked me if I would design some of his CD covers, which I did as a project. So we did the CD and a few singles using landscapes. That seemed to fit the kind of moody, slightly longing music that they make.

JULIAN OPIE

Perhaps following on from that, or maybe from somewhere else, I did a project with the magazine *Sleaze Nation*. They asked me to do a series of portraits without any explanation, just page after page, very straight, very big, and they printed them beautifully. I think, from that, my work reached a slightly different audience, which was a more cross-media design audience, which I hadn't really reached before to such a degree. I think that one of the design groups that saw it was asked by EMI to come up with a possible project for the Blur album.

They came and saw me as they had the idea to do my style on some photos they had of the four band members. At that stage I tried to photograph all the band members. In the end I only photographed two of them in terms of actually using my photographs. The two others had had haircuts and they wanted to be depicted in the way that their fans knew them. I think they were right in the end. I fought it a bit at the time but in retrospect I think it worked better that they looked very recognizable. I think we all agreed that the four of them in a kind of *Let It Be* format was going to be the answer, with the four different background colours.

For me, going into record shops and seeing them in their little plastic covers was very exciting. I didn't really foresee that I'd also be seeing them on billboards and buses, which perhaps some people would be disturbed by.

I play with images and then I define them as objects. So the portraits exist – well, they don't exist. They exist as digital files and at that point I don't deem them to be artworks yet, but they're finished in a way. It's an odd stage. Once I've got that image there, I can use it for whatever I want.

There's a feeling, I think, which comes from a confusion about materials really, that it should only be one thing. With photography that has been resolved. People decide what the edition is, and that's done. But with digital files it hasn't really been resolved. I am interested in playing with it, and sometimes I push it this way or that. Generally I try not to edition things because I feel that it confuses me. I do make some edition prints, and I try to make that have its own internal sense, but generally I just make one and then I move on to the next thing. With the portraits though, since it's not work, it's not art when it's this digital thing, it can be many things.

For instance, the picture of Graham the guitarist is part of the CD cover project. It's also a painting about 35 centimetres large. That size relates to something that might feel like a little icon, a little private portrait. There's then a size which is kind of impressionist-easel size on a sort of domestic scale, and that's in the National Portrait Gallery. There is also a size, which is modern art size for big American apartments, and then there's another size that I hardly ever make, but it's a very different object, it's billboard size, it's historical painting size. It has a very different quality. The head is bigger, at three or four metres high. It really overwhelms the space that it's in, because it becomes like something in a church.

So I've got this one little digital image which is usable in that way. I also sometimes make them on wallpaper in black and white, and that can be any size and has a very different quality. It's almost non-

existent. It's like a film and it transforms architecture. There's a project in Japan, which I don't think they're going to accept, but if they were to accept it, it would be the size of a skyscraper. The whole side of an opera house building would have a portrait of someone that would be very muted in black and white, not with the full colour. The drawings themselves then become almost like a tool, something intermediary between the finish and the beginning. I like the idea of using the same drawing, and seeing what it can do, almost like when you make scientific experiments. You need a control. Some elements have to stay the same so that you can understand what the changes are. At the same time, it's very convenient. It means that if I've done a drawing of someone, which takes quite a long time and is quite intensive – if I'm happy with it – there are a number of things I can do with it. I can play with it for longer.

It could be greedy but I try to use everything that's available to me in order to function. On the other hand I also get scared of putting things out and having things seen. I work between the two feelings, but certainly a poster or an invite card or a catalogue is for me as exciting, potentially, as a gallery wall. They have different qualities. It's exciting because when you're dealing with another white room, you only have a certain number of moves. I mean, an infinite number of moves within that, but there are parameters. Whereas a catalogue, for example, allows you to do different things. I see it as a challenge. I also have ideas for making a set of stamps. Stamps are great little things, and the fact that they can be stuck in different places seems nice. So I'm always on the lookout for different possibilities.

The Lisson catalogue is such an interesting object and statement. You said you don't take positions, but couldn't it be seen as a critique of the art market?

Julian Opie: I have what I call my archive and every piece of work I make goes onto a page, along with the other similar works. I put the titles in and I send it off to the galleries I work with, and I try to make sure that they're up to date with it. I try to put the prices on it too, because otherwise no one knows the prices. They keep going around and up and down, and everyone's arguing about what we said last time. This way it's all down there and the catalogue really is an expanded version of my archive.

I saw the catalogue as a way of expanding the ideas of the show really and musing on commercialism, commercial galleries, selling work – how that all ties in. I didn't put the catalogue out to mock anything or to undermine anything really, except presuppositions. You know – the idea that art has to be separate from all that. If there's anything that I don't like it's this romantic, I would say, somewhat right-wing attitude, that art should keep its hands clean, that it should be separate. I see things written where people decry the use of computers or cars in artworks. 'Where are the trees?' they shout. Well, you know, the trees are being pulped to make the newspaper you're writing in, for one thing. And you're writing on a computer anyway, and you probably got there by car, so what's wrong with you? Why deny the reality of your existence in favour of some fantasy, which is a borrowed one. Inevitably it's borrowed, because it's not your reality. So, if anything, it's a desire to plunge into what seems to be real, realistic.

JULIAN OPIE

On the other hand I like to have fun, and to mix things up. I like putting the prices in. It's a natural logical step if you're going to make a catalogue. It would seem almost cowardly not to put the prices in. I kind of knew that it's not what you expect, and it's somewhat agitating to see those prices there and perhaps even shocking. I mean a lot of the fabricators who make work for me find those prices shocking because, you know, they do the work, and normally the things that they fabricate of that type don't sell for that much. But I think that it would have been a less realistic drawing if I'd left the prices out.

I really like the idea of making work and putting it out in a way that follows its own internal logic, rather than putting art out in the places and in the way that art is supposed to be put out. So I'm playing and circling my own tail in terms of reference and logic, and, in a certain way, cooking with my eyes shut, adding the things that I like, finding combinations that seem to work without having a meaning, or a programme, or an idea really that I want to tell people. I'm busy enjoying myself and experimenting,

Junction-13, 2001

trying things out and judging myself. I'm in a constant state of looking and judging – did that work? Is that mark nice? Right down to the details.

You talk about not having a position, but isn't what you're doing the equivalent of advertising or graphic design or image-making in other contexts, or is there something distinct from graphic design?

Julian Opie: Graphics is art, and I'm making art. Whether it looks graphicky, whether it uses some existing graphics that are out in the world, is another thing. It's not so much that I use existing graphics, but that I play into the fact that people know the world through graphics. So graphics is, in a broader sense, perhaps a visual language that is an existing visual language.

Are you competing with advertising? Are you aware of the other languages, of the street or the magazine?

Julian Opie: I don't find that looking at either advertising or graphics in terms of magazines and media is ever very useful for me. There's something too arty about it, whereas a road sign, because of its pure functionality, is useful. On the other hand, I do feel much more competitive with advertising and graphics, because they get to be seen so much. I don't feel competitive in the sense that I want to be them. I feel competitive in that I want their space. I'd like to have the billboards, or, if not, I'd like to get rid of the billboards so that we can see the towns behind them. I resent them quite intensely in fact. I don't resent magazines in the same way because they build their own space, and you can have it if you want to.

I really like not putting art out in the places and in the way that art is supposed to be put out. There is a structure. It's a loose one, and it changes over the years, but it's very easy to take for granted. You know, there are museums who phone you up and ask you if you'd like to do a show, if you're lucky. And there are galleries that work with you and produce little catalogues to help selling, but they're not presented that way, because they're supposed to be there to show the work, but they're used for selling, and that's why they'll fund them. The museum will fund them because they want to promote their museum, and also, ostensibly, for a kind of educational furthering of the exhibition. That's fine, but I would just like to see what would happen if you didn't follow that pre-digested route and I just thought, well, I really like CD covers. I actually think they're like a little portable framed painting, with glass on the front, that you see in all sorts of places. And that, therefore, is a possible place in which to work. It's not that I want to compete with other graphic designers in any way. It's simply that there is a way in which one could make art and present it in a different context. In the old days, there were church walls. They were the only available place to put your pictures, apart from the castle walls with tapestries. The church walls were plastered. They were flat and so on, and they were great. Now, I think, there are untold possibilities. When they come up, I kind of grab at them, and while I'm making work, sometimes the work itself suggests them.

JULIAN OPIE

What ultimately is your sense of the world that you're creating?

Julian Opie: When people look at art there's a slight desire for – if not answers, then at least a position – which I find odd really, because I have no position. Not one that I would clearly either be able to articulate, or definitely one that I would want to force somebody else to have. I don't think people listen to a CD and end up thinking, 'Yes, but what was the position of that music?' I would definitely shy away from trying to set up some kind of belief structure that could be gained or learnt. For one thing, I think it would very much subsume the art that was going on in there. I don't think people bring this same need to a lot of other forms of expression. These things are really about looking at things. They're not about reading them, or translating them into something else. They are there in the finished form.

MARK WALLINGER

I think there is a lot of flummery in the art world, a lot of mystification, and it seems to me that the visual arts should be visual – and that is how I hope to capture people.

BIOGRAPHY

Mark Wallinger was born in Chigwell, Essex, in 1959. He
trained at Chelsea School of Art, London, before studying for
an MA at Goldsmiths' College, London. After graduating in
1985, most of his degree show was exhibited by the Anthony
Reynolds Gallery, and he continued to teach part-time at
Goldsmiths'.

Wallinger was shortlisted for the Turner Prize in 1995 and his
work was later included in the controversial 'Sensation'
exhibition at the Royal Academy in 1997. The following year
he was awarded the prestigious Henry Moore Fellowship at
the British School in Rome. In 2000 he became a Research
Fellow at the University of Central England, Birmingham, and
the next year he took up a residency on the DAAD Arts
Programme in Berlin. Wallinger was chosen to represent
Britain at the 49th Venice Biennale in 2001.

Working with a diverse range of media including sculpture,
video and installation, Wallinger's art is often witty and
immediately accessible, yet at the same time it engages with
some of the traditional grand themes, including religion,
spirituality, identity and death. He is best known for the
sculpture *Ecce Homo* placed on the empty fourth plinth in
Trafalgar Square in 1999.

Mark Wallinger currently lives in the Charlottenburg district of
Berlin, and is represented by the Anthony Reynolds Gallery. He
was interviewed at his apartment in London in November 2001.

How was it to show as Britain's official representative at the Venice Biennale in 2001?

Mark Wallinger: I was told that I was to be Britain's representative just over a year beforehand so I was able to get out there the June before, just before they installed the architectural Biennale, to look at the space, and I really liked it. It was the only pavilion that wasn't purpose-built, and it did seem to have some of the old Victorian swagger about it, at the top of the only hill in Venice that I could discern. It was attractive and was going to be a challenge that I would relish.

Façade is a life-size colour photograph depicting the British Pavilion mounted on vinyl-coated polyester on scaffolding in front of the building. It ensures that the visitor is confronted by an image of the actual space they are entering, creating the effect of stepping into an illusionary landscape. Please talk about Façade and how your ideas for it developed.

Mark Wallinger: In much the same way as *Ecce Homo* came to me, in thinking in terms of the context of the time and place, the very particular context of the Venice Biennale and the position of the British Pavilion was almost its own incitement to the work. I mean, because it looked as if it was trying to lord it over the other pavilions, which were all bristling with their own nationalist motifs and

Façade, 2001

because the British one was at the end of a long avenue from the entrance and on a hill, this notion of the *trompe l'oeil* just came to me.

Because of the expectations of how I was going to handle the politics of both this event and what those pavilions represent, I was never going to be able to treat the pavilion as an inert box for showing discrete artworks. At the same time, I didn't want to make too much of a song and dance about all that because I'm a little tired of being branded as someone who deals principally with the British or Englishness.

So I hoped this façade would let the air out of the pumped-up nationalism a bit and people could pass through it and then perhaps into a slightly different frame of mind for the works inside.

You started as a painter but you don't paint any longer. Why has this changed?

Mark Wallinger: I've always had a tricky relationship with painting. It feels as much as though it's given up on me as I've given up on it! I did try and make a painting for the Venice Biennale, which was never going to work really, but it was an act of defiance: I just wanted to show that I could still make a painting.

Capital (detail), 1990

I do believe that painting kind of fell to earth somewhere in the 60s, that its trajectory had been completed, so that in painting nowadays it is as difficult to be innocent as it is to be knowing or ironic. Both have a problem because the whole history of art is just a sort of resource for raiding, or for ignoring. Painting is restricted in what it can talk about or define. In actual fact, I think that it's quite strange that it has retained its place as the dominant medium so long after photography and film and video.

For all these reasons, I prefer new media; it gives you an excitement about the possibilities of the form. For instance, my work with video is often playing with time, which is kind of what you do in an editing suite.

Is it too simple to say you gave up on painting because you couldn't make political paintings?

Mark Wallinger: I was interested in the politics of representation. In the 80s, industry was being systematically dismantled by Thatcherism, and at the same time this kind of burgeoning heritage industry, a kind of Never-Never Land, was being proposed for Britain and it lacked any social programme. So it seemed to me that I should address or investigate where this kind of imagery had come from and how the reactionary Right find it a rallying point. I was able to do that by dipping in and out of a 'golden age' of English painting and using it as a resource that I hoped would have some resonance with urban decay and the different kind of nationhood that one gets used to seeing in South London.

The way I tackled all that was very fastidious and very deliberate, though. If you work with video you set yourself certain strictures and you've got a very good idea of what you're going to do at every point; but then serendipity takes over and you know the best bits you just can't predict. Because you have a tight enough container for them, you get a bonus that you don't really get with painting.

But you are still interested in referencing that English culture. What relationship is there in your work to English Romantic cultural traditions?

Mark Wallinger: My interest in Shelley and all of that comes from a stay I had at the British School in Rome and visiting the Protestant cemetery where I came across Shelley's tomb. I'd gone to Rome to do some writing and I became interested in sonnets, which is an Italian form, and one thing led to another really. My *Prometheus* piece represents that first point in the Enlightenment, the first great cautionary tale about what man meddles with in terms of science, interfering with nature or playing God. This resonates to this day with the fears surrounding genetic research. I found it fascinating. Prometheus and Frankenstein, I think, are universal stories and so it's not entirely English Romantic poetry that got me to that point.

Opposite *The Word in the Desert 1*, 2000

Please talk about Ghost*: what is it and how did the work originate?*

Mark Wallinger: *Ghost* is my version, but its ancestor is Stubbs' painting *Whistlejacket*, which has pride of place in the National Gallery at the moment. You can view it through doorway after doorway.

It came as a result of a residency I had at the university museum of natural history in Oxford. I was so overwhelmed by the range in terms of species and in terms of time and it was very hard to come up with an artwork knowing that. So actually the unicorn struck me as a notion of something that was a kind of retort really, in the face of all this plenitude of species. Here was an animal that everyone could describe but that didn't ever exist! So then it becomes a sort of problem-solving exercise: how do I do it? Do I produce a skeleton of this thing? And then suddenly the image of *Whistlejacket* came to me. At first I was going to try and make a painting that adapted Stubbs' work, which was a bit of hubris really, wasn't it? But eventually I turned it into a black-and-white negative and I just kind of knew this was going to be the way forward. It had that quality of an X-ray. I do love this notion of X-raying paintings as if there is a sort of a pathology that will get you back to some true source of what they really mean. And then it was just a matter of Photoshopping the horn. It is a fantastic painting because it's just like one seamless gesture really, isn't it? It's just incredible.

Who is the audience? Who did you make the work for?

Mark Wallinger: I have them at my shoulder in a way; friends or allies or people I've known down the years. Quite a lot of them are not artists, but people that I think, well, if I can engage them with this, then I'm probably not going too far wrong.

Is it important that the audience stretches beyond the art world?

Mark Wallinger: Yes, and I think making *Ecce Homo* was an experience that was particularly gratifying in that it's the only piece of work I've ever made that meets directly with the public without being mediated through any institution or curator. The kind of reaction I got from that was quite amazing, quite humbling really. So I know I can reach a general audience, but that's not to say that I'm deliberately making things easily accessible. I think there is a lot of flummery in the art world, a lot of mystification, and it seems to me that the visual arts should be visual – and that is how I hope to capture people.

Could you talk about your passion for racing? Why was it so important to you and how did it come to influence your work?

Mark Wallinger: Racing for a long time was something I wanted to keep out of my art; I'm somebody who likes their own personal space away from art and the art world. And so it was my hobby, my passion. But it suddenly struck me that the racing world did operate as a world within a world, and that world was a kind of exaggerated microcosm of British society. You're either upper class or you're mucking out the stables. Things get stretched and accentuated. It tickled me no end that the aristocracy have been playing eugenics with horses down the years, obsessed with blood lines and the efficacy of a good marriage.

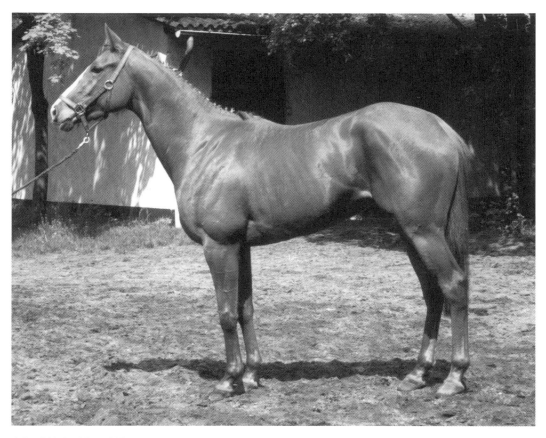

A Real Work of Art, 1993

And then there were things to do with identity. I mean, it's a lovely teaser to come up with an individual set of colours, a design, which can represent one for the rest of one's life. But that is just part of a highly aestheticized world. It's very hard to unpick where nature and where culture is located because the thoroughbred has been bred and inbred and wouldn't have its existence without us. Witnessing the covering shed as well is to experience the really quite stark and staggering mixture of instinct and economics that happens there.

So for many reasons, I knew it would bear fruit, and at the same time I envisaged it as a kind of self-contained project, that it would have a kind of end, and the owning and naming of *A Real Work of Art* seemed to be the logical end point.

What is the story behind your work A Real Work of Art?

Mark Wallinger: *A Real Work of Art* was an attempt to kind of try and push further the Duchampian notion that an artist can nominate anything from the real quotidian world out there and bless it with

aesthetic significance. Because generally speaking, the legacy of the readymade has been rather lazily interpreted; what generally happens is someone drags something out of context into the glare of a museum, institution or art gallery and the authority of that rubs off on this object, which seems to me an entirely conservative gesture in that it's only the institution that has the power. So I was hoping that I might be able to nominate not only an object, but a living object that would exist as an artwork without ever going near a gallery. Just go about its daily business.

And did it work?

Mark Wallinger: Well, it would have worked better if we'd been luckier and if she'd run, say, ten or a dozen times in that season. Then hopefully there would have been a little bit of a bandwagon or a word of mouth or there'd have been a bit more publicity. Her every run would be televised all over the country, because there are bookmakers in every nook and cranny of the country that cover these things live.

So her performances were open to everyone, which I rather liked, and her form and her rating meant she would have a very specific meaning for a system of expertise that is probably every bit as complex as anything within the art world. It was totally opaque to the art world.

Unfortunately she got injured at the beginning of the season and injured during her one and only race. But essentially I think that the naming was the all-important thing and anything afterwards was secondary.

And how did you support her?

Mark Wallinger: There was a syndicate of twelve people who contributed to the project and we raised the money. I made an edition of a little trophy maquette with her jockey wearing my colours. In the end it did cost quite a lot of money.

Ecce Homo (Behold the Man) *is a life-size figure of Christ that was placed on the edge of the fourth plinth in Trafalgar Square in 1999. It is, perhaps, your best known piece of work. Tell us what* Ecce Homo *was and where it came from.*

Mark Wallinger: *Ecce Homo* was an experience that was particularly gratifying and it's one of those ideas that just came very fast; I had it all down the same day. When I was first approached it was on the understanding that the most popular of the three plinth designs chosen might well end up there permanently in Trafalgar Square.

It was proposed midway through 1998, but the first work was probably going to be there over the Millennium. And the Millennium at that point was just the Millennium Dome and everyone was too squeamish, it seemed, to mention Christianity or the 2000 years since what? It was more like

Opposite *Ecce Homo*, 1999

watching the noughts go over on your milometer. And I was thinking about how the Square really is the place of the people in this country. So those two things combined and presented me with the notion of *Ecce Homo* and that moment where he is, in secular terms, a political prisoner brought before a lynch mob. In Christian terms I think it's the moment where he faces up to destiny. I mean, it's always seemed to me to be almost the most powerful moment in the gospel, but it's one that's pretty under-represented in sculpture, I suppose because it's so undemonstrative.

How was the sculpture cast?

Mark Wallinger: I knew life-size was going to be important as well, and I quite liked the fact that putting a figure on a plinth is wholly unremarkable. I found a company who can make resin look like marble as well as bronze. I wanted to use a real person and cast from a real person. The thing I didn't want to do was go out and choose my Christ. I didn't know what to do. Eventually I went to the workshop and met this guy who was down to his boxer shorts within two minutes of me meeting him, which doesn't happen very often! His physique and bearing were perfect and he was actually wearing a crucifix: his father's a vicar, it turns out, so I didn't exactly have to coach him in this moment. I think that kind of helped as well. So we proceeded from there.

Did Ecce Homo *get a strong reaction?*

Mark Wallinger: I think the public did take to it, which was great. That was a great feeling, although almost before it went up, I was preparing myself for the moment it came down, because I knew there would be some kind of anticlimax.

The obvious shift in your work is from politics to metaphysics. Is that what happened?

Mark Wallinger: Well, I think I reached a natural end point to a lot of work about five years ago, post-Turner Prize. I needed to leave my studio quickly and so my work got stuck in storage and a couple of months later I found a new studio, so it was like starting again. But I didn't know where things were going to go. I just used to come in every day and if I had half a notion that survived to the end of the day, then it got put up on the wall, and I proceeded like that. I've never really worked with a sketchbook before, but I got into this. So it became a process of trying to fill the walls to show myself how inventive I was, or not! It was a kind of editing process, and they found their own hierarchy in terms of which may or may not be made.

But there was developing, I suppose, a continuing interest in illusion and perspective and viewpoint – and just the making of meaning. I think I wanted to challenge myself a little bit further, lay myself on the line a bit more. I'd used mirrors and palindromes before, as well as perspective in an old series called *School*, and these things just emerged. I suppose *Angel* was the piece that showed me I was, perhaps, heading in the right direction. It was something I managed to complete early on in the latest body of work, which gave me the encouragement to go on.

MARK WALLINGER

Angel, 1997

Describe Angel.

Mark Wallinger: I became fixated on the opening of St John's Gospel. Even if one doesn't even understand it in theological terms, it is just the most amazing language. But at the same time, as Beckett said, 'In the Beginning was the pun', so within itself it sows the seeds for its own logical demise.

I hesitate to use the word deconstruct, because that's not strictly what I mean, but it demonstrates that our relationship to the scriptures, or the scriptures' relationship to faith, is really similar to our relationship to language. That there is a leap of faith that has to be made, that there isn't any causal connection, you can literally read the Bible backwards and it's not going to make you a believer. I don't know the Bible backwards, but because I like playing with oppositions, I thought what's the opposite of perfect sense?

How did you set about producing the artwork?

Mark Wallinger: I basically set out to learn the first five verses of St John phonetically backwards, which took me about three months. By that time I'd worked out that I wanted to use the escalators on the London Underground, that I wanted it to kind of be this strange messenger, some kind of angel, perhaps, who was possessed by this scripture and repeats it. In time it developed into a trilogy, a

speaking in tongues trilogy, but at that point I knew I needed a persona to do this in and so I came out with this Blind Faith character.

There was the added benefit that because I'm wearing dark glasses I could have an idiot board around the camera and no one could see that I was looking at the text written out phonetically. The dark glasses also mean that the viewer concentrates on my mouth more, and hopefully realizes that I did it live in one take and there's no trickery in the studio afterwards. I had a Walkman with an ear-piece feeding me the soundtrack again and again, so I seem overcome by the message. I think it might have stemmed from when I saw Richard Eyre's production of *Hamlet* with Jonathan Pryce in 1980 at the Royal Court Theatre where the ghost of his father actually invades him.

When we asked London Underground for exclusive use of a middle escalator, they gave us Angel station, so that's serendipity again. Our camera operator realized that she could get an amazing shot which would include the two escalators either side all the way to the top, and so it becomes a little bit like a kind of Last Judgement: the damned and the saved on either side. The whole thing is simply reversed. I knew the escalator would give me the theatre I needed; that I'd be walking on the spot and

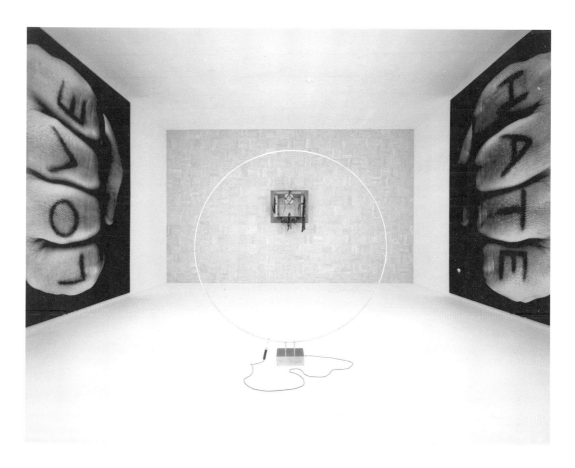

then at the end I'd be carried off. *Zadok the Priest* was the most climactic piece of music I knew, so that's the story there.

Prometheus *is very much the centre-piece of your No Man's Land exhibition at the Whitechapel Gallery in 2001. It is a visually powerful and disturbing installation. Can you describe it?*

Mark Wallinger: *Prometheus* is a large installation with an outer corridor around an inner chamber, the doors of which automatically open as one nears them. So one is thrown into the perspective of a kind of God's-eye view looking down into an execution chamber and onto an electric chair, in front of which (or in essence above) is this big round aerial-looking thing. On opposing walls are two huge fists – blown-up photos of my fists tattooed with 'LOVE' and 'HATE' – which is a borrowing from *Night of the Hunter*. The whole thing's lit from behind, i.e., above.

The video component, which is outside and acts like a witness to the execution, has me dourly singing this Ariel song from *The Tempest*. I became fascinated with the song and the notion of sea-

Opposite *Prometheus*, 1999

Frames from *On an Operating Table*, 1998

change. A fragment of it appears on Shelley's tomb. Shelley drowned and I then discovered that Shelley's boat was called *Ariel*, so they're interconnecting literary conceits, if you like. Basically I'm singing a song (in the guise of Blind Faith) which celebrates things ever-changing: that things mutate and change and fade and grow. I get to the end of that and then the tape rewinds, so I let out this high-pitched scream and appear to have a jolt of electricity and then I'm back to the beginning again.

It replays Prometheus' fate, chained to a rock and having his liver eaten out every day, which then renews itself every night. So I am in this purgatorial but defiant and dour position. I suppose it is a kind of cautionary tale again: if we play God, it is as likely to be destructive as constructive.

Circles crop up quite a lot within the show and the circle of tubular steel is made to my Vitruvian proportions. I wanted to make electricity palpable in a way other than light, and I was struck by the memories of old fêtes where one plays the game of trying to get the loop along the bendy wire. So I thought it would be quite nice if we had this thing buzzing the whole time, unless or until someone picks it up.

The remarkable use of light in On an Operating Table *suggests a drifting in and out of consciousness. How did you conceive the work and what message did you want it to bring?*

Mark Wallinger: *On an Operating Table* is a video work. The image you see is of the light in a neurological operating theatre, and I was very struck by how much like an eye it is, with an iris and a pupil. I just played with the focus-pull on the camera and fantastically enough, these lights have dimmer switches – although I can't imagine why you'd want low lighting for a brain operation – but it allowed me to play with the brightness and that was as sophisticated as it got in terms of shooting.

The soundtrack goes back to the beginning of the Gospel of St John and I've arranged the letters of the opening verse in the form of an optician's eye chart. What you're hearing is a number of people trying to read from the eye chart. I played with the soundtrack to try and capture that strange aural experience you have just as you're going in or out of consciousness, or dropping off in front of the telly, or coming to from an operation. These were projected very large in the Whitechapel Gallery and I quite like the fact that, whilst in *Prometheus* you're looking down, so to speak, with a God's-eye view, here you're flipped through 180 degrees the opposite way.

Time and Relative Dimensions in Space *is a mirrored version of the 'Tardis', which featured in the British TV series* Dr Who. *How did the project come about and how did you try to represent what is really only a conceptual excursion?*

Mark Wallinger: I have made a couple of site-specific Tardises for the Oxford museum of natural history. The museum was rather like a time machine, a powerhouse of Victorian thinkers and imagination. I wanted to make something that stood as a metaphor for that: all that excitement,

Opposite *Time and Relative Dimensions in Space*, 2001

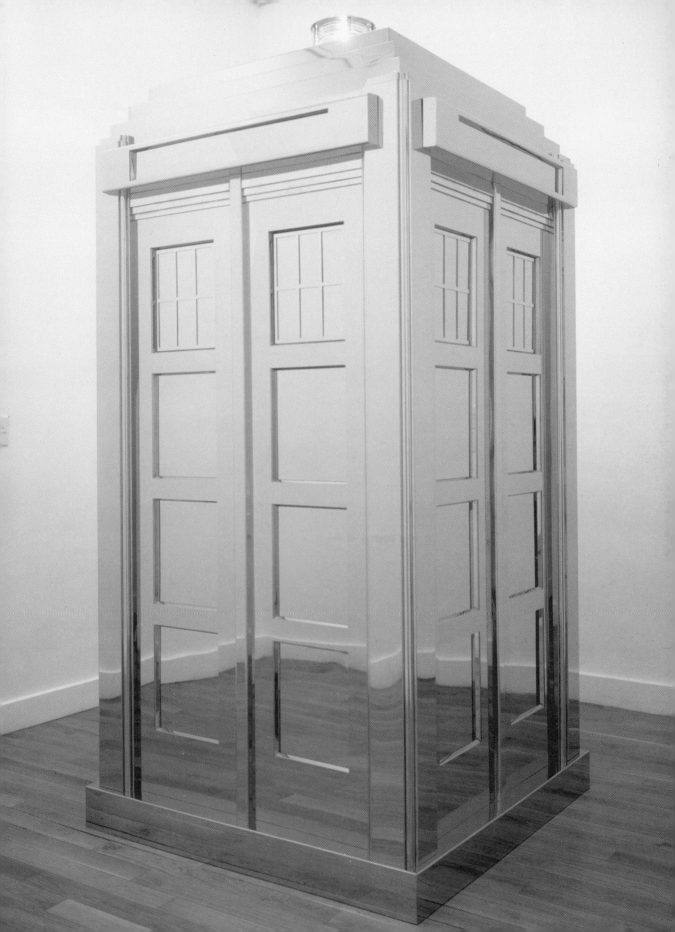

something that would appeal to children maybe. So it was a kind of playful version, and I had one on the lawn outside as if it had just landed there, and another one secreted in the collection in a position where you couldn't see both at once. So the conceit was that one of them might have travelled.

It's an absurd object in that it's got double doors on all four sides, so it's almost like a conjuror's box already. It was famously larger inside than outside, and I think it was the fact that it could move through time that was deliciously scary as a child. To be lost as a child was the worst thing, but to be lost not only in space, but also in time, that was really lost. It was the notion that it was larger inside than outside and that the thing used to disappear led me to the notion of trying to do a mirrored version. It was like an object trying to shrug off its physicality, but at the same time it is a kind of totem of popular culture. For a lot of people around my generation it is part of the mythology, as much a part as *Prometheus*.

Describe the modus operandi for the video work Threshold to the Kingdom.

Mark Wallinger: We got to London City Airport before the first flight came in and set up. International arrivals have these automatically triggered double doors, which I thought were fantastic. It really is a threshold. There are not many airports where that drama is played out in quite this way, where the delineation is so utterly clear.

The video is eleven minutes and fifteen seconds long and shows people emerging from international arrivals, through the doors. I suppose it's another one where you get some lucky breaks, so that the doors closing properly was the perfect point to dissolve to the next bit I wanted to show. The dissolve itself made people ghostly or disappear. The 51st Psalm is a plea to be cleansed, a plea of contrition to a merciful God. Somehow I made this connection myself with the airport. For years I thought I was terrified of flying, but actually it's airports that wind me up more: it's this absolute no man's land that I just feel so uncomfortable with.

What part does your own belief play in these works?

Mark Wallinger: I think the project's coming from two directions in a sense. There's a yearning, a desire, that everyone feels at one time or another for transcendent meaning. From the other side, it's the residue of a majority religious perspective within this secular world. There are verifiable and identifiable ways of suggesting a spirituality, and one can be moved by church music as an unbeliever, and so understand the rhetoric and how this works – and you can allow yourself to be immersed in it, or not.

Is this the sentiment you were reflecting in Threshold to the Kingdom?

Mark Wallinger: A good example is *Threshold to the Kingdom*, which uses the choral music of Allegri's *Miserere*. The sentiment of the words of the 51st Psalm fitted perfectly with what I was trying to do. 'Kingdom' is a pun on United Kingdom and the Kingdom of Heaven. This may seem to be slightly sentimental, that one achieves this uplift by using this kind of music. Or one might say that

actually the very same guilt and awkwardness that we find in that movement through no man's land at an airport through Customs is the state at its most palpable, when one actually feels its force. This seems to me rather similar to confession and absolution. Both are controlling and coercive of certain behaviour.

There is an insistence on death in the No Man's Land exhibition, but is the work intended to be gloomy?

Mark Wallinger: Death is very much a recurring motif in the exhibition, which seems to focus on doorways and circles and destination. This body of work did seem to sit together pretty coherently, with death as the common element, but it is also blackly comic, say, in a piece like *Fly*. It's almost an impossible dream in the Circle Line piece *When Parallel Lines Meet at Infinity*, which has this black spot at the vanishing point which sometimes seems to be moving. If I had the right technology, then perhaps this would be endless, it would be an eternity.

I suppose I'm framing images of solace. It's the ineffable, isn't it?

MARTIN CREED

The only thing that I feel like I know is that I want to make things. Other than that, I feel like I don't know.

BIOGRAPHY

Martin Creed was born in Wakefield, Yorkshire, in 1968. He studied at the Slade School of Fine Art, London, from 1986 to 1990.

His first solo exhibition took place in 1993 in London. Since then he has exhibited widely in Europe and North America and has participated in a number of important group exhibitions, including Life/Live, Paris and Lisbon (1996–97) and Speed at the Whitechapel Art Gallery, London, in 1998.

Creed was commissioned to create a large neon text that reads *EVERYTHING IS GOING TO BE ALRIGHT* for the entablature of The Portico, a landmark listed site in Clapton, East London, in 1999. A similar work, *the whole world + the work = the whole world*, was made for the façade of the new Tate Britain as part of its opening show in 2000. In 2001, he was awarded the Turner Prize for his solo travelling exhibition, MARTINCREEDWORKS, organized by Southampton City Art Gallery in 2000.

Creed's self-effacing work reflects an anxiety to communicate in a world already full of too many things. He frequently tries to produce both something and nothing, and does so in idiosyncratic ways with the modest means of everyday life. His sculptures, installations, interventions and statements illustrate how simple, ordinary objects, seen in new ways, can suggest often complex and contradictory meanings. His musical compositions, performed with the band owada, have been written around his works to allow for a more intimate and shared experience than that derived from an individually owned piece of artwork.

Martin Creed currently lives and works in Italy and is represented by Cabinet. He was interviewed at his studio in London in March 2000.

MARTIN CREED

How do you describe what you do? Is it art?

Martin Creed: Well, I would not describe it as art. I mean, I don't really know what to describe it as. What I do is try to make things and try to do things – and whether it's art or not, you know, I don't find that a useful question.

Where you were born and can you say something about your upbringing?

Martin Creed: I was born in Wakefield in Yorkshire, but we moved to Scotland when I was three, so I grew up in Scotland, in a suburb of Glasgow. And then I came to London when I was about seventeen to the Slade School of Art.

Why did you come to the Slade?

Martin Creed: Well, I think because it was famous. At the time, it was one of the big art schools that I knew of in London. But also I think because I got into the Slade on the basis of drawings of the figure and landscapes, and there's a part of the Slade which is very big on that.

So did you start as a traditional artist?

Martin Creed: Yes. I think art at school more or less means still lives and paintings, paintings equal art. Aye, that's how I got into it.

Is your Scottishness important?

Martin Creed: No, I don't think the Scottishness is so important. No.

You don't describe yourself as a Scottish artist?

Martin Creed: No. No, no. I don't describe myself as an artist. But I do not describe myself as a Scottish artist, no.

What's the earliest work that you think of as your work now? How did you start? What's the first work?

Martin Creed: Well, there was a point where I started numbering the works, which I did because I didn't want to give them titles and I thought that titles were pinning the work down. And also because words are another medium that took it somewhere else. And so I started numbering them because I wanted to treat them all the same. I mean, I wanted a way of identifying them and also because I wanted them all to be somehow the same whether they were pieces of music or little things or big things. And when I started numbering the works, I back numbered. But I didn't want there to be a work number one because I didn't feel comfortable about having the first work. So there's a kind of fade in, there's a work number three, but there isn't a first work.

And work number three is?

Martin Creed: It's a yellow painting.

MARTIN CREED

Is it fair to say that the earlier works are more obviously art object works, either paintings or sculptural objects?

Martin Creed: Probably. I started out trying to paint and I was in a painting department at art school, and I think I was trying to paint, you know, because I was in a painting department at art school. And because painting equals art in many people's minds. I still feel like the work comes out of trying to make paintings actually. I remember stopping painting because I wanted to work out what was going on. I felt like I was kind of waving my arm around in mid air and I was thinking, you know, I'm only making paintings because of a tradition in relation to painting and art, and also because I was studying painting. So I was thinking, I was trying to work out what I was doing. And then I ended up thinking that I won't try to make a painting but I'll try to work out what a painting is. Which was quite difficult to do, except that mostly they're on walls. And I was thinking more then of trying to make a thing for a wall rather than a painting, and thinking that it's OK to make something for a wall because people can see things when they're on walls, you know. Because of the way their eyes face out of their heads.

So was there an epiphanic moment or work where you just thought I can't make paintings, I'm not going make paintings, but I know what I am going to do?

Martin Creed: Well, there were these works I made which I think of as being like paintings; they're made from canvas. I was trying to think of it more as a thing on a wall and then trying to come up with a composition and also the materials and shapes through the problems of trying to put something on a wall. And these are paintings which use the brackets, the mirror plates, as the starting point for the composition. They were important to me because the work came about quite directly through the process. It's the process I think which was important.

Can we talk about specific pieces? Work No. 79: Some Blu-Tack kneaded, rolled into a ball, and depressed against a wall.

Martin Creed: The work with Blu-Tack started out like all the works as an attempt to make something. The only thing that I feel like I know is that I want to make things. Other than that, I feel like I don't know. So the problem is in trying to make something without knowing what I want. In the case of the Blu-Tack and in some of the other works which use kind of adhesives, I was thinking about making something in the world. I mean, I was thinking about the fact that when you do something or make something it's always something extra for the world. And I was thinking about where the join is between the thing you do and the world, and how it joins, and whether it's something separate or whether it's something which is just a part of the world. As a consequence of thinking about the join between what you do and everything else, I was looking literally at adhesives and adhesive tapes and ways of sticking, and I tried using Blu-Tack just because it was one of the most available ways to stick something on. I didn't use the Blu-Tack to stick something because there was nothing I wanted to stick, you know, so I just used the Blu-Tack.

MARTIN CREED

That's quite a lot of weight for such a tiny thing to carry. There's a certain kind of philosophical reflection there about the world and objects and so forth, which is a lot to lay on a very fragile or modest object.

Martin Creed: I would not lay anything that I've just said to you upon that object. Speaking about the objects and the things which I do, you know, I'm speaking about it in the only way I can. I'm thinking about what I think. I would not lay anything upon any of the things which I make, because I don't believe that it's possible to communicate like that. I think it's all to do with *wanting* to communicate. I mean, I think I want to make things because I want to communicate with people, because I want to be loved, because I want to express myself.

Work No. 88: A sheet of A4 paper crumpled into a ball. *A work that's been called your signature work.*

Martin Creed: The crumpled ball of paper came about as an attempt to make something from a piece of paper. I made that at a time when I had very little money, and to make a ball out of the paper seemed like the most simple shape that I could make out of it. The sphere is equal in all directions and it's a simple shape. But it was just an attempt to make something using a piece of paper. One of the things I like about it is that it kind of disappears when you put it in the world and it can be something quite precious and it's also a piece of rubbish. I like that about it.

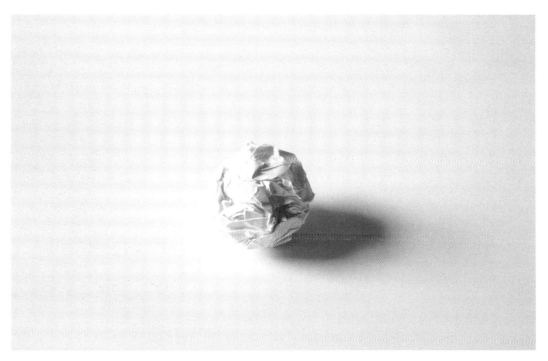

Work No. 88: A sheet of A4 paper crumpled into a ball, 1995

MARTIN CREED

So is it the object that's important there or is it the idea of making that from a sheet of paper?

Martin Creed: I can't separate the object from the idea and I wouldn't. I find it difficult to separate anything in my head, you know, feelings from thoughts, sensations, you know, it's all just a blur.

The next one on my list is Work No. 102: A protrusion from a wall.

Martin Creed: I think the protrusion from the wall came from trying to paint. And then not feeling able to paint, not feeling able to choose colours or decide what to do with them. And then thinking more about trying to make something on a wall rather than a painting. So it was an attempt to make something for a wall, so all I had to do was choose, decide what material to use, what shape to make and how big to make it. But I couldn't decide what material to use, and so I used the same material as the wall. And then I used this shape which is like a kind of bell shape, which I thought was a kind of simple and efficient way of making something happen on a wall. So it comes up from the surface at a tangent, goes round and goes back, all using the same curve. And it all happens in a circle, so it happens equally in every direction. So something happens on the wall, in the material of the wall: I had decided on the material and also on the shape. And then I just had to decide how big to make it. I decided that by taking the diameter of a painting roller, and I just made sure that the curve was bigger than the diameter of a roller, so that it doesn't get stuck when you paint it. That gave me the size, it was just a bit bigger so that the curve was generous enough to make it easy to paint over. If

Work No. 188: Two protrusions from a wall, 1998

the wall was yellow, then the work would be yellow, and if the wall was green, then the work would be green.

Why is it so hard to make those decisions about what colour something might be or what shape something might be?

Martin Creed: Well, I find it difficult to make decisions about anything. I mean, I don't feel I have any basis on which to make decisions, other than on the basis that I don't know. And also on the basis that I want to do things, you know, and make things. I mean, the big problem as I see it is that you have to decide or you have to make decisions if you want to do anything. But I think that it's possible to decide without choosing, you know. You can choose everything, you can say yes *and* no. It's important to me, I think, to try to get into the work a kind of equal positive and negative, and that's important because I don't feel sure, you know, I'm worried, I don't want to get it wrong. So if I can make the thing and also not make it at the same time, somehow then I feel happy. That kind of equal positive and negative, I think, is in some works more obviously than in others.

Can you give us some examples?

Martin Creed: Well, for example, there's a work which uses the same shape as the wall protrusions, the big wall protrusions, but it's much smaller. One goes into the wall and the other one comes out. That came before the bigger wall protrusion, and again that was an attempt to make something for a wall. But I couldn't decide, starting from the surface of a wall, I couldn't decide whether to go in or come out. And so the work does both, it goes in and it comes out. Also with the lights going on and off and the door opening and closing. To me they're all ways of having something, of doing something, making something happen, but in a way without anything happening. The light's just doing what it does, you know, and the door's just doing what it does.

The way that I think about the work in my head sometimes is that it's like an equation, and so you start from nothing, from zero, having not made anything, and you try to make something, and you do. So it's like zero plus one which is the thing. And then also trying not to make it because I don't feel sure about making it. But I want to make it. But I don't feel sure about it, you know, confident about saying this is a great big thing that I want to make. So that's like minus one, the trying not to make it. So it's zero plus one minus one equals zero. So it's like a kind of equation, but in the middle something happens, and that's the work.

Describing it like that it sounds very cerebral. And yet there are times when you also talk about it as being very much about emotions. You just talked about making the work because you wanted to be loved. Is it cerebral, is it emotional?

Martin Creed: Well, to me it's emotional. Aye. To me that's the starting point. I mean, I do it because I *want* to make something. I think that's a desire, you know, or a need. I think that I recognize that I want to make something, and so I try to make something. But then you get to thinking about it and

MARTIN CREED

Work No. 81: A 1" cubic stack of masking tape in the middle of every wall in a building, 1993

that's where the problems start because you can't help thinking about it, wondering whether it's good or bad. But to me it's emotional more than anything else.

Do you expect people to find that emotion in the work?

Martin Creed: Not necessarily, no.

Let me put it another way. Is it important what people bring to the work? Can you speak about the way in which you hope or expect or think that people will look at the work?

Martin Creed: I find it very difficult to think about what people will think of the work or bring to it. It's because of people that I make the work, because I'm sure it's got something to do with other people, with wanting to communicate and wanting to say hello. People are free you know, they think what they think. I don't think that it's possible to plan for that. To me it's more important that there's kind of space for people, that there's space in the work for people if they want to come in. And that there's also space if they don't. I'd like the work to be like a football that can take being kicked around by different kinds of players.

MARTIN CREED

Can I go back to another work? Can I ask about Work No. 189: 39 metronomes beating time, one at each speed?

Martin Creed: Originally I made a work with one metronome. I was invited to take part in an exhibition that was just for a weekend, so I was very aware it was on for a limited amount of time. I was looking for a way of passing the time and metronomes are designed for passing the time. And I wanted to get thirty-nine metronomes at that time, but I couldn't afford it. Because I wanted to use the metronomes to pass the time but I didn't want to choose at what speed the time should be passed. So I used a single metronome, at a moderate speed. To me, the work that's most important with the metronomes is the one which uses thirty-nine metronomes, so there's one metronome working at every possible speed. Because this type of classical metronome has thirty-nine speeds. So there's thirty-nine metronomes, each one working at a different speed. It's an attempt to decide without choosing.

A lot of your works are funny. Is that important? Is humour in your work important?

Martin Creed: I'm happy if the work's funny. But I think it's difficult, again like guessing what people are going to think, I think it's difficult to make it funny. Like trying to make people think something. I can't do that, and I don't think anyone can really do that. But most of the work I like makes me laugh.

Work No. 200: Half the air in a given space, 1998

MARTIN CREED

Balloons make people laugh. Can we talk about Work No. 200: Half the air in a given space?

Martin Creed: The balloons started out again as an attempt to make something. For a long time I've been trying to use air to make something because I think it's the perfect material. Air is not a choice, it's everywhere and we need it. When you go to an art gallery it's always full of air, and so I was trying to work out a way of using air as a material to make something. In the end I used balloons because I thought it was obvious that balloons are the simplest, most available way to package air, to make it visible. So I decided to use the balloons. And then I calculated the volume of a given space and half filled it with balloons, which was partly to balance the making of something and the not making of something. But also because if the room was full of balloons, you know, no one would be able to get in. And it's important to me with the balloon work, it's important that the situation is normal, that, as usual, the space is full of air, it's just that half of it inside the balloons.

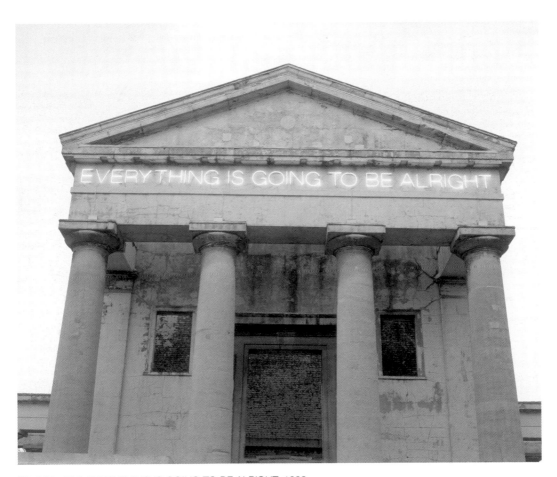

Work No. 203: EVERYTHING IS GOING TO BE ALRIGHT, 1999

MARTIN CREED

Tell me about the piece for Southampton called Work No.128: All the sculpture in a collection

Martin Creed: This work consisted of arranging or collecting all the works in one collection in one place. To me it was an attempt to make something without choosing, without deciding. And it was important that it was all the work in the collection, and it's all kind of treated equally. So in a way to me it's very similar to the metronome work.

And the neon signs? Would you talk about the neons?

Martin Creed: The neon works are more . . . what's the word? The neon works are more 'there' than some of the other work. Some of the other work gets absorbed often into the environment in which it is, or it is literally part of the architecture. And the neons are much more separate, in a way they're more like paintings, I think. But one of the things I like about neon is that it can be switched off. And that makes me feel more comfortable with it than if it couldn't be switched off.

I started using neon because of this work that I made in Clapton on this old desolate building, and there the neon was used as a practical solution to the problem of having something be readable at night. Someone found the building, found out who owned it and she invited me to try to make something there. And I found it very difficult because the building's so amazing. I did not want to compete with the building. I felt like the one place that I could do something was on the entablature or rather the frieze area of the entablature, without really competing with the building. I thought I could maybe write something there, but I didn't know what to write. And the phrase, 'everything is going to be alright', came about from working with various options in my mind on what I could write there. The thing had to be of a certain length because I wanted it to fill up the entablature from left to right. And it came from thinking partly about the original use of the building, which was as an orphanage, and after that it became the Salvation Army headquarters. I was very depressed when I made that and so the phrase, 'everything is going to be alright', seemed to work. It kind of made me feel better. But also I feel like the phrase contains the negative, um . . . in the sense that it implies that things aren't all right.

So it's not simply optimistic?

Martin Creed: Well, yes it is. To me it's optimistic. But to me it also contains the negative, the opposite. But I'm into it in an optimistic way. I used the neon, in the case of that work, partly because it's a very dark site: the neon meant it could be seen. The other neon works which I've made since then have really come from that one. I think I've been using words more lately, and I think that's as a result of having to use words to describe some of the works. Especially what you might call the installations. They usually have to be described using words on paper. In fact most of the works exist as scores or instructions on paper. They are, to me, like pieces of music, in the sense that they exist as a score which can be realised, which can be played. And the way it's played can be changed.

MARTIN CREED

Can we talk about just one more neon piece, which is the piece for the front of Tate Britain?

Martin Creed: The phrase, 'the whole world + the work = the whole world', was written originally as an attempt to write about the work. I mean, to write about trying to make work. Trying to work out what was happening, trying to work out what I was doing. And finding it impossible to separate anything. Feeling that everything's connected, feeling that I can't separate what's in my head from what's around me. And that when you do something you're always doing it in the world, and it always has an effect on the world however small or big. Anything anyone does has the same effect. And that you just can't distinguish between things, or I don't feel like I can distinguish between things. Also I think a feeling that anything can have value, or not.

What led to the work being put on the front of Tate Britain?

Martin Creed: They invited proposals for works on the outside of the building, and I proposed this. I felt that this piece of writing could work on the Tate. With it being an art gallery, I suppose it gives this text a context, which I think it would not have had, for example, if it had been on the building in Clapton.

Some of the pieces, including perhaps that one, and certainly something like the sculpture piece, could be seen as commentaries on the processes of museums and collecting and the whole art system. Are they intended as some kind of commentary on that?

Martin Creed: They're not intended as a commentary on the art world. They come about through the process of trying to make something. Artists try to make things, and they do, and they do it in a context. They do it where they can and they find a way of doing it, or maybe they don't find a way of doing it. When you put something in an art gallery, you can't avoid the fact that it's an art gallery.

Is it important to see yourself in a tradition? Do you see yourself in a tradition of conceptual art?

Martin Creed: No.

So what's your sense of a relationship to conceptual art which some people would very easily push your work into?

Martin Creed: I like a lot of what people call conceptual art, but I wouldn't really like to distinguish between the different types of art. I mean, I like a lot of things. I don't really think of it in a sort of historical way. When I'm trying to make things, I don't find it very useful to look at other examples of made things, because then I get all confused, and I already feel confused.

Do you see yourself influenced by anybody?

Martin Creed: I think it's difficult to say who or what might influence you. I think I am influenced by many things. But I would not particularly think of one or two.

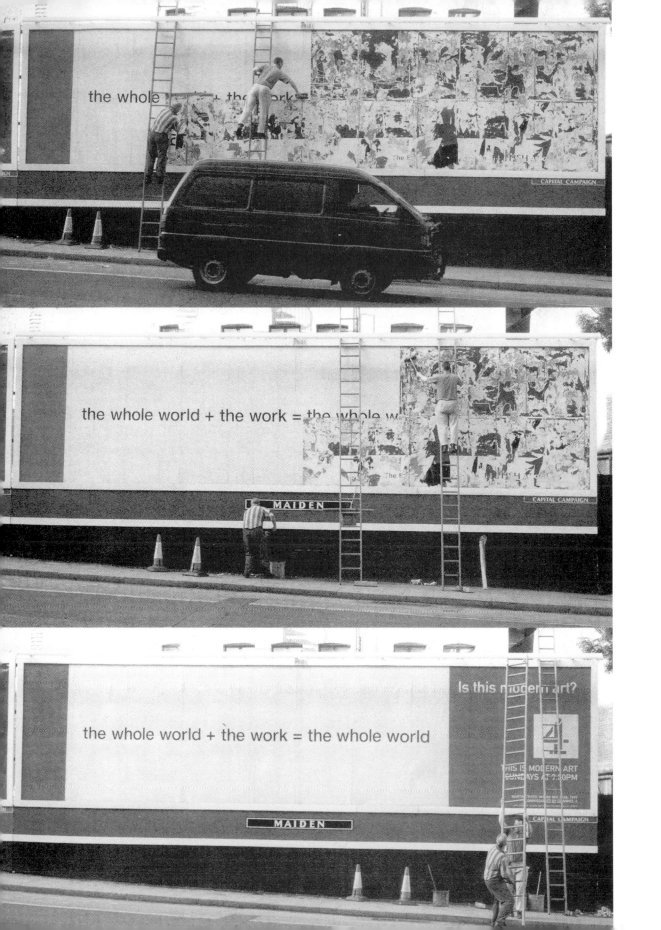

MARTIN CREED

John Cage?

Martin Creed: I like John Cage, but I like Elvis more. And I like Mozart, and the Beatles and Frank Sinatra.

And Bruce Naumann?

Martin Creed: I like Bruce Naumann, yup. I like coffee and I like donuts. I like eating. That's important.

The work is very limited in a certain kind of good way. Are you very aware of your limitations as somebody making things?

Martin Creed: I feel that it all comes from limitations, yes. In fact I think that a lot of the work comes about through a kind of failure, you know, a feeling of total limitation which affects the result. But I think limitations make things possible, you know. Without them it's impossible to do anything. The four walls that limit a room or the six strings that make a guitar. When someone designed the metronome they had to decide how many speeds they were going to have, to more or less cover all the possible speeds at which people might want to play music. And they had to limit it, otherwise it was impossible. So I think that limitations are very important.

It's also very modest work.

Martin Creed: Right.

Are you a modest person?

Martin Creed: I don't know if I'm modest, really. I think that if there's modesty about any of the work it's only because I feel unsure. I mean, I want to make really big beautiful things. And then they end up, you know, like that.

Are you anxious about making things when you make them?

Martin Creed: Sometimes I think, when I'm working, sometimes I think I've got to . . . got to live with this for the rest of my life. And that makes me anxious. And I think it's to do with fear, you know. A lot of it. I want to make things but then I'm scared of something. Scared of making something that's terrible, you know. I'd hate that.

So is there anything you look back on and think, that's terrible?

Martin Creed: There's a few things that I'm not so happy with, but in general I can live with most of it. That's the most important thing to me, to be able to feel that I can live with it. I want to make things that I can live with, aye.

Opposite Channel 4 posters depicting *Work No. 143⁸: the whole world + the work = the whole world*

Blow And Suck

From none	Blow	More
Take one	Suck	Less
Add one		Yes
Make none	From none	
	Take one	From none
To none	Add one	To some
Add three	Make none	
Take two		To none
Make one	To none	
	Add three	Add up
From one	Take two	Get up
Take N	Make one	Take up
Add S		Make up
And M	From one	Keep up
	Take N	Keep up
Make some	Add S	Keep up
From none	And M	Keep up
Take some		Stay up
Make none	Make some	Grow up
	From none	Give up
From none	Take some	Let up
To some	Make none	
From some		And blow
To none	From none	And suck
	To some	And blow
None	From some	And suck
Some	To none	And blow
More		And suck
Less	None	And blow
	Some	And suck
Blow	More	
Suck	Less	
	No	

Work No. 208: Blow and Suck, 1996

Can we talk about the music? You write and compose and play individually and with a band, with owada. There's also obviously interesting parallels, as you talked a little about, between creating scores and creating music and creating descriptions or recipes. Can you talk about the relationship between the music and making things?

Martin Creed: I don't think it's so different to try to write a piece of music for piano or guitar than to try to make something for a wall. It's just helpful for me to have a starting point, if it's a wall or a guitar or a piano. I think that the reason that I tried to write pieces of music originally . . . well the first pieces that I wrote were because I was thinking about the process. . . . The process is important to me. . . . Once it's made then people do with it what they like, they think what they like. But what enables me to do it is the involvement in the process. I felt that for example with the wall protrusion piece, what was important to me was the process from the point at which nothing had been made, through trying to decide on the material, the size, the shape and how that led to the final result. So in my mind that work is really a line of decisions, one after the other, from the initial desire to make something, then to limiting it to trying to make something for a wall, then to thinking about some of the practical problems

as well as the really big problems about what materials you use and what shapes you make. And I feel what's important to me about that work is, yes, this line of decisions, this process.

In a piece of music, I felt that it was possible to show the process, in time, more overtly than in the visual works where you just see the end result. I found out a lot about the, whatever you call it, the sculpture, from doing some of the music. What I also like about it is that it's at the same time very physical. When you're playing live really loudly, the sound hits you physically. And yet it's just in the air, it's nothing. And that appeals to me.

Can you describe owada?

Martin Creed: I wrote some of these pieces of music and I wrote them for bass guitar and drums. And they were written out in a way like classical music. And I wanted to try them out and I had a friend, Keiko, Keiko Owada, who was in a band. And so I played them with Keiko playing the bass and Fiona playing the drums. Keiko and Fiona were in this other band together. And we played these first pieces that I'd written, and then I wrote some more and then we started playing some gigs. Eventually Adam joined as the drummer, so now it's me, Adam and Keiko.

Do you find it difficult talking about what you do?

Martin Creed: I don't know. I find it difficult to talk about what I do but I quite like it. I mean, I quite like trying to talk about it. Trying to talk about what I do, it's not very different from trying to do what I do. It's trying to do something. But I like trying to talk about it, in the sense that sometimes I find out things by talking. Or listening.

Given how difficult it is to make things and make decisions or choices in your practice, do you have the same difficulty in your life?

Martin Creed: I find it difficult to decide what colour shirt to wear and I'm terrible at buying things, you know. I do find it difficult to decide things and I think it's difficult to draw a line between work, making work and everything else in your life. It's difficult but . . . no, it's not that difficult. What I mean is that I like it when decisions make themselves. And I like it if that can happen in the work. Because that often happens, you know, things happen by accident, and you meet someone, or you don't. Life isn't necessarily just a sequence of big decisions. It's the same when you're trying to make something, you know, that decisions sometimes make themselves. Or because of the limitations of the materials or the situation, certain things are impossible and you can't do them.

Is that an avoidance of responsibility?

Martin Creed: No, no, I think it's the opposite, isn't it?

MARTIN CREED

If by not making decisions, by letting things happen or working with the limitations, are you avoiding responsibility for the authorship of the work, the making of the work, or for all I know the way you live your life?

Martin Creed: That's difficult. I don't think it's avoidance of responsibility. I think that the fear comes from thinking, you know: I'm responsible for this. Therefore I don't want to get it wrong, you know, or end up with something that I can't live with. So if responsibility comes into it, it comes in that way. In the sense that you're responsible for what you do and that affects other people and can't be separated from other people really, or from anything else.

What the work isn't about seemingly is all the things that art or music might be thought to be about: beauty, love, passion, politics . . .

Martin Creed: Well, I don't agree with that. I think the work is to do with . . . this is difficult . . . well to me it's absolutely about love. And beauty. It goes without saying that it's about politics. I just think that there's no way to separate any of those.

If someone didn't immediately see that it was about love and beauty and politics, is it worthwhile for you to try and persuade them?

Martin Creed: No. If someone said that they thought that what I do isn't art then I would not argue with them. Or if they thought it was not beautiful I would not argue with them. Because I'm not really sure what it is, you know. But I like it when people like it.

Can you speak about the text pieces?

Martin Creed: Some of those pieces with text on paper, the way that I think about them is I relate them to function. Let's say you want to make a doorknob, the fact that a doorknob is functional is the useful limitation that you need to make it. It relates to the human hand and it's a starting point that enables you to make the doorknob. The problem with making something that doesn't have a direct physical function is that you don't have necessarily those same limitations, the same kind of parameters with which to work. You're not building a house so it doesn't have to have a roof, it doesn't have to be waterproof.

In the case of the texts on paper, which for example describe within them where they should be placed, the way I see those is something similar maybe to the design idea about function and form. So the one thing leads to the other and back again. And so the instruction about where to put the work is the work, which gives me the way of making the work and it's kind of circular. But I think as well that those pieces with words on paper are to me kind of like drawings, you know, they're attempts to work something out which is not necessarily visible in some of the finished pieces, which are maybe more opaque.

MARTIN CREED

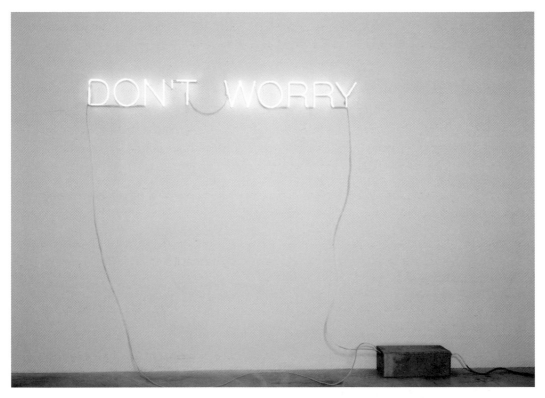

Work No. 220: DON'T WORRY, 1999

Your room with the door . . . that's something that you've found, you haven't created it . . . Obviously you've got to use opportunities that you find – can you speak about that?

Martin Creed: To me the difference between, say, a work like the door opening and closing and the light going on and off, the difference between that and one of, say, the cubes made out of masking tape or the paintings is that the work with the door is an attempt to make something, well rather than an attempt to make something, more it's an attempt to make something happen. So there's no material being added. Stuff that's already there is being used, the door is being made to do what it does and also the light, and together they make something. But no extra materials are being added, apart from the door operator to make it happen. Nothing's been brought in and that relates to an anxiety that I feel about adding stuff to the world and feeling that it's difficult to do that. That it's difficult to do that and to find a reason to do it.

LIST OF ILLUSTRATIONS

Antony Gormley
(Courtesy of Antony Gormley)

Angel of the North, 1998
Still IV, 2001
European Field (detail), 1993
Sound II, 1986
Allotment II, 1996
Bed, 1981
Quantum Cloud, 1999
Critical Mass II, 1995
Iron: Man, 1993
Casting process in the television series
State of the Art, 1987
A View: A Place, 1985–86
Testing a World View, 1993
Three Ways: Mould, Hole and Passage, 1981

Howard Hodgkin
(Courtesy of Gagosian Gallery, London, and
Anthony d'Offay Gallery, London)

Americana, 1999–2001
After Vuillard, 1996–2002
Rain at Il Palazzo, 1993–98
The last time I saw Paris, 1988–91
Out of the Window, 2000
Chez Max, 1996–97
Rain, 1984–89
Clean Sheets, 1982–84
In Bed in Venice, 1984–88
Mr. and Mrs. E.J.P., 1972–73
Out of the Window, 2000
Memories, 1997–99

Rachel Whiteread
(Courtesy of Anthony d'Offay Gallery, London)

Untitled (House), 1993
Monument, 2001
Untitled (Amber Slab), 1991
Untitled (Novels), 1999
Water Tower, 1998
Holocaust Memorial, 2000
Untitled (Upstairs), 2001
Untitled (Pair), 1999
Ghost, 1990
Untitled (Torso), 1992–95

Julian Opie
(Courtesy of Lisson Gallery, London)

Eight Lost Animals, 2001
My aunt's sheep, 1997
Alex, bassist, 2000
Wind Planes Silence, 2001
Waves Seagulls Voices, 2000
Blur Portraits, 2000
Remember them 1, 2001
Imagine you are driving 2, 1997
Tower, 2001
Junction-13, 2001

Mark Wallinger
(Courtesy of Anthony Reynolds Gallery, London)

Ecce Homo, 1999
Threshold to the Kingdom, 2000
Ghost, 2001
Self Portrait as Emily Davison, 1993
Prometheus, 1999
A Real Work of Art, 1993
The Word in the Desert I, 2000
Frames from *On an Operating Table*, 1998
Time and Relative Dimensions in Space, 2001
Façade, 2001
Angel, 1997
Capital (detail), 1990

Martin Creed
(Courtesy of Cabinet, London)

Work No. 227: The lights going on and off, 2000
Work No. 200: Half the air in a given space, 1998
*Work No. 79: Some Blu-Tack kneaded, rolled
into a ball, and depressed against a wall*, 1993
Work No. 188: Two protrusions from a wall, 1998
Channel 4 posters depicting *Work No. 143B: the
whole world + the work = the whole world*, 1999
*Work No. 203: EVERYTHING IS GOING TO BE
ALRIGHT*, 1999
*Work No. 81: A 1" cubic stack of masking tape in
the middle of every wall in a building*, 1993
Work No. 208: Blow and Suck, 1996
*Work No. 88: A sheet of A4 paper crumpled into
a ball*, 1995
Work No. 220: DON'T WORRY, 1999